MODERN CARTOONING

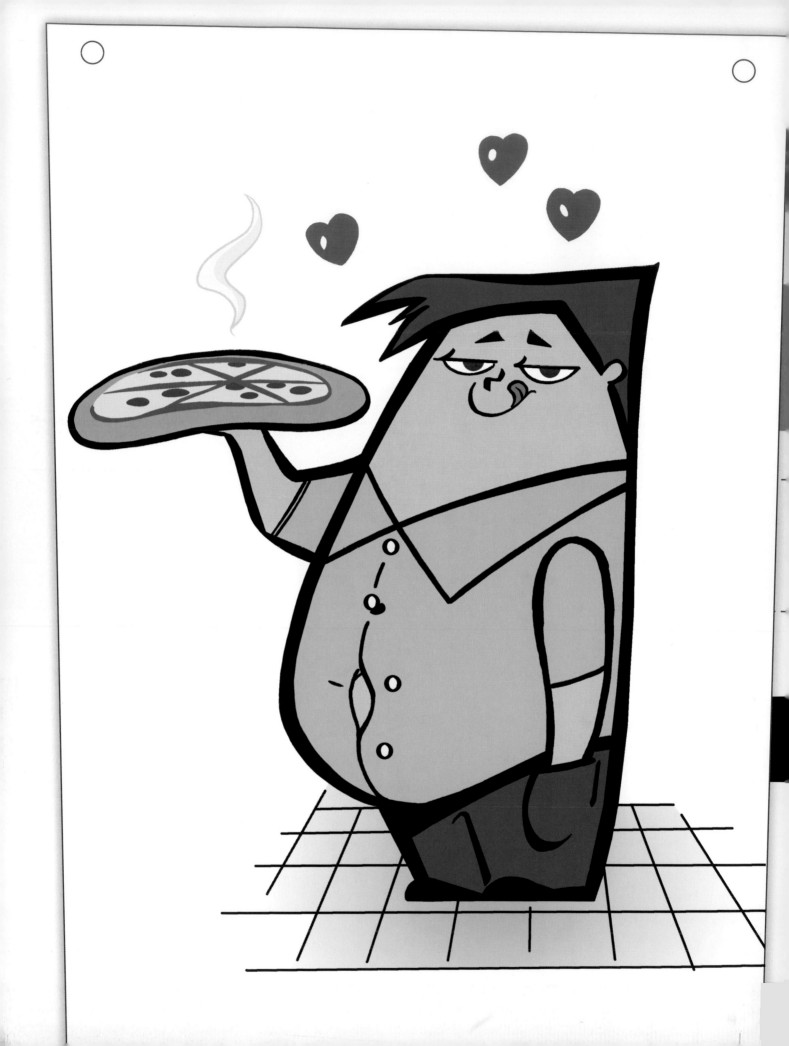

MODERN CARTOONING

ESSENTIAL TECHNIQUES *for* DRAWING TODAY'S POPULAR CARTOONS

CHRISTOPHER HART

Watson-Guptill Publications

New York

Library of Congress Cataloging-in-Publication Data
Hart, Christopher
 Modern cartooning : essential techniques for drawing today's popular cartoons /
Christopher Hart. — First Edition.
 Includes index.
1. Cartoon characters. 2. Cartooning—Technique. I. Title.
 NC1764.H377 2013
 741.5'1–dc23

 2012013977

ISBN 978-0-8230-0714-1
eISBN 978-0-8230-0715-8

Printed in China

Book design by M.80 Design
Covert art by Christopher Hart

10 9 8 7 6 5 4 3 2

First Edition

DEDICATED TO ALL ASPIRING CARTOONISTS EVERYWHERE!

CONTENTS

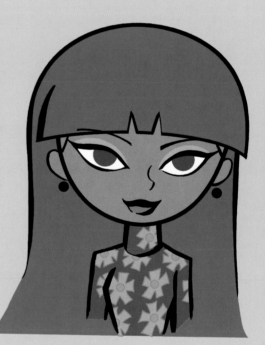

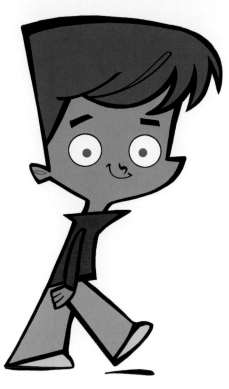

INTRODUCTION

This is the first cartooning book specifically designed for the person who has never drawn cartoons before. With carefully crafted, clear step-by-step drawings and an amazing abundance of hints and tips, you'll gain the confidence and skill needed to draw cartoons the way you've always wanted to.

I'll show you how to draw great-looking characters right away. The trick is to learn how to draw the basic head shapes and apply facial features from a wide selection of the most popular types in cartooning today. You'll start with a circle, then discover new shapes. I'll show you how to mold the head into new and unique shapes to convey humorous and highly entertaining attitudes.

For this book, I created the "Universal Body Shape." I'll also show you how to use a basic rectangle to create the foundation for just about every type of character. How easy is that?

You'll learn all of these secrets and more. I'll also show you how to take established art techniques and tweak them to create humorous and often clueless cartoon characters. You'll amaze your friends. You'll crush your enemies. Hey, how many cartooning books can promise all that?

Welcome to the world of cartooning. The chapters ahead are funny, cute, and crazy. So take out your pencil. Wait. That was a little slow. Try it again. Okay, ready? Now! Oh, almost! Oh, what the heck, let's get started.

BASIC
HEAD SHAPE

First, let's examine the various theories of cartooning from a contextual standpoint. Just kidding! Let's just start drawing instead!

You may wonder if it's possible to create stylish and contemporary cartoons by beginning at a basic level. You foolish, foolish mortal. The faces you're going to begin with are easy to draw, but they're also character designs of a high level that are entertaining and stuffed with personality. You can achieve these results by the creative use of a few simple head shapes, combined with the right types of facial features. But there's more to it than that. My approach to cartooning stresses the construction of the head shape (in this case, a circle). Head shapes should remain *conspicuous,* even in the final character design. This technique causes the outline of the head to appear as a primary feature of your cartoon character, like cartoon eyes or noses. The basic head construction does not just serve as a guideline for the finished drawing; it becomes a caricature of a "regular" head.

It used to be that the initial foundation of the head was there to simply get the drawing started, and was later forgotten. Oh, how young and innocent cartoonists were back then! But enough of this forced walk down memory lane—let's get started!

THE CIRCLE

Many cartoonists start cartoons with a circle, but then modify it at their first opportunity. Why? The circle is a pleasing shape. Roundness is an appealing element in many character designs. But the simplicity of the circle can also become a liability. The circle is such a common shape that it does not always command the viewer's attention.

But you can create excitement for your circle-based characters by making them so simplistic and round that they look amusingly absurd. And you don't have to start with a perfect circle! A sloppy hand-drawn circle is fine. You won't get a bad grade for not doing everything perfectly. At least, not a really bad grade.

The circle works best for boys, girls, and female teen characters. You can also create older characters with this starting point, but it takes more inventiveness to pull it off. Circles tend to make everyone look young.

MISCHIEVOUS KID ------------------------------------

Here's a cute kid with mpd (mischievous personality disorder). Please don't leave any weapons-grade nuclear material near him—just to be extra cautious. You don't want to know what almost happened last time someone forgot to put away the plutonium.

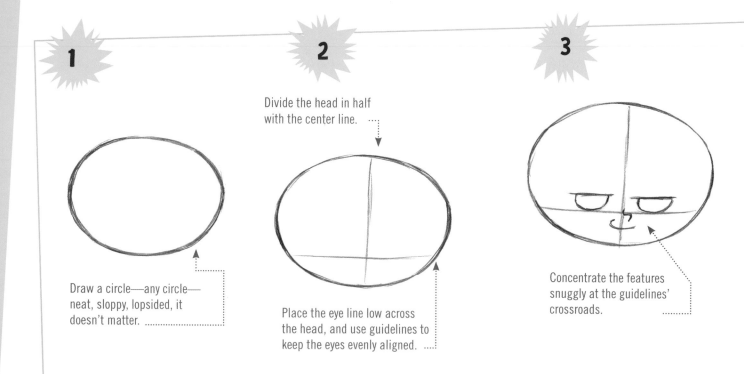

1

Draw a circle—any circle— neat, sloppy, lopsided, it doesn't matter.

2

Divide the head in half with the center line.

Place the eye line low across the head, and use guidelines to keep the eyes evenly aligned.

3

Concentrate the features snuggly at the guidelines' crossroads.

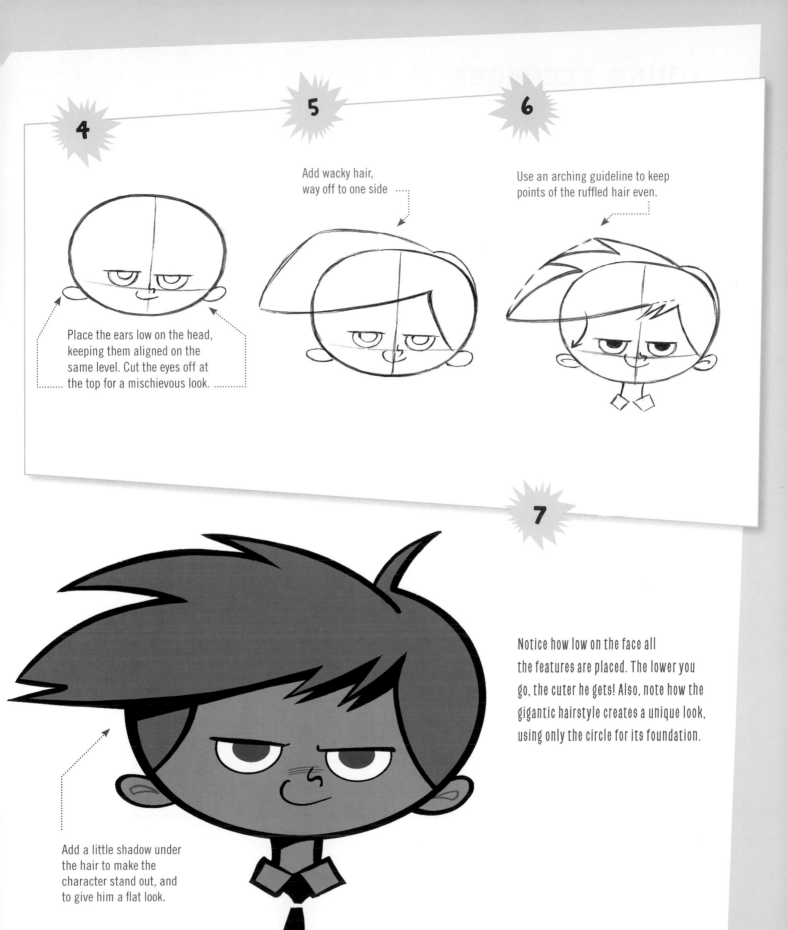

4

5

6

Place the ears low on the head, keeping them aligned on the same level. Cut the eyes off at the top for a mischievous look.

Add wacky hair, way off to one side

Use an arching guideline to keep points of the ruffled hair even.

7

Notice how low on the face all the features are placed. The lower you go, the cuter he gets! Also, note how the gigantic hairstyle creates a unique look, using only the circle for its foundation.

Add a little shadow under the hair to make the character stand out, and to give him a flat look.

YOUNG TEENAGER

Youngsters of around twelve to fourteen make particularly popular cartoon characters. They still have the round faces and big, perky eyes of youth. Add more stuff: makeup, pigtails, dangling earrings, and a summer top. Pigtails and dangling earrings enhance the appeal of this character. Aspiring cartoonists often see these touches as afterthoughts. They are not. They are an essential part of the character design. Change her clothing, hair, and accessories, and you've practically created a new character.

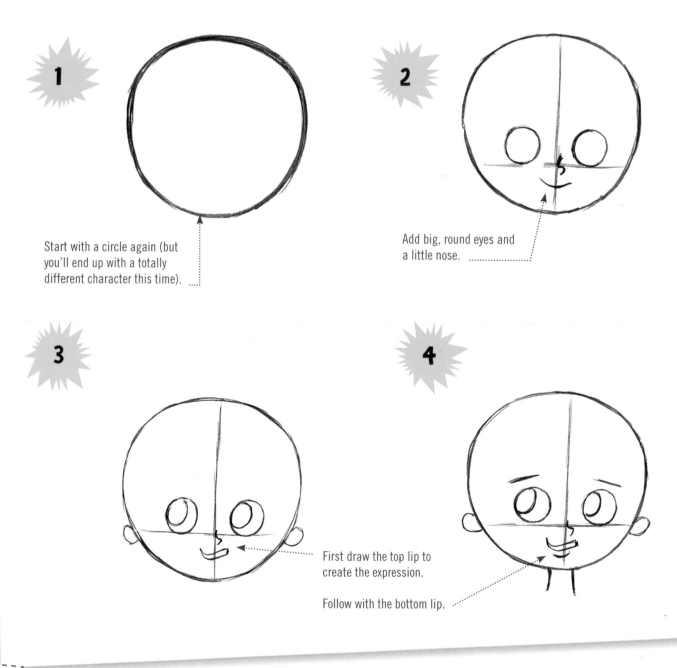

1 Start with a circle again (but you'll end up with a totally different character this time).

2 Add big, round eyes and a little nose.

3 First draw the top lip to create the expression.

Follow with the bottom lip.

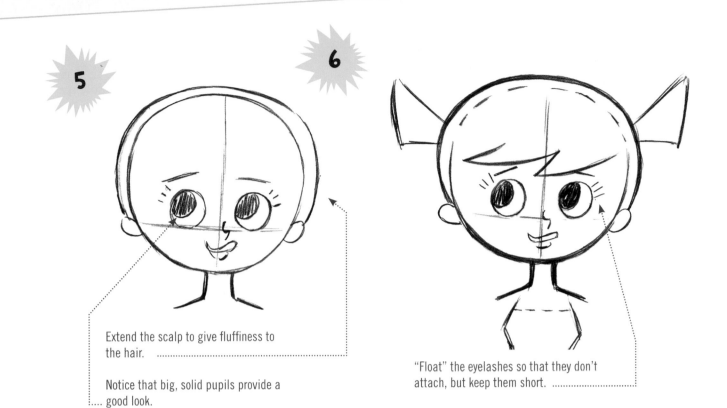

5

Extend the scalp to give fluffiness to the hair.

Notice that big, solid pupils provide a good look.

6

"Float" the eyelashes so that they don't attach, but keep them short.

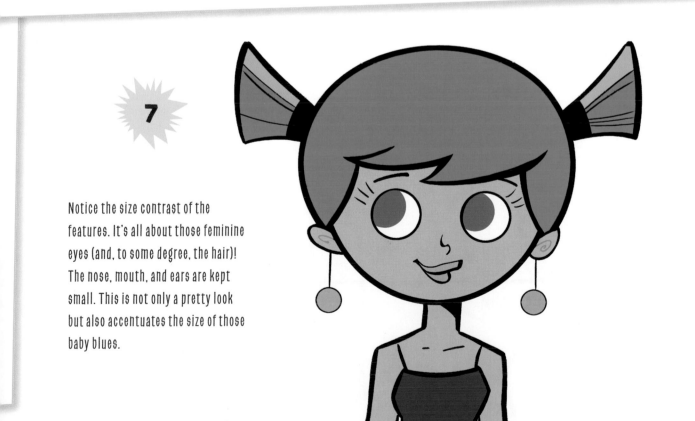

7

Notice the size contrast of the features. It's all about those feminine eyes (and, to some degree, the hair)! The nose, mouth, and ears are kept small. This is not only a pretty look but also accentuates the size of those baby blues.

SWEET SIXTEEN ---

This character can be a girl by day and a superspy at night. All pretty teens in cartoons are capable of fantastic adventures. But whether or not her hobby is cracking the codes of foreign governments, the secret of her charm lies in her cute but capable appearance, her leadership abilities, and her meltdowns when her crush fails to notice her.

Compared to the younger teen on page 15, the size of a mid-teen's head is somewhat reduced, relative to her facial features. In other words, there is less surface area surrounding her eyes, nose, and mouth, giving her face a more streamlined look—even though it is still based on a circle!

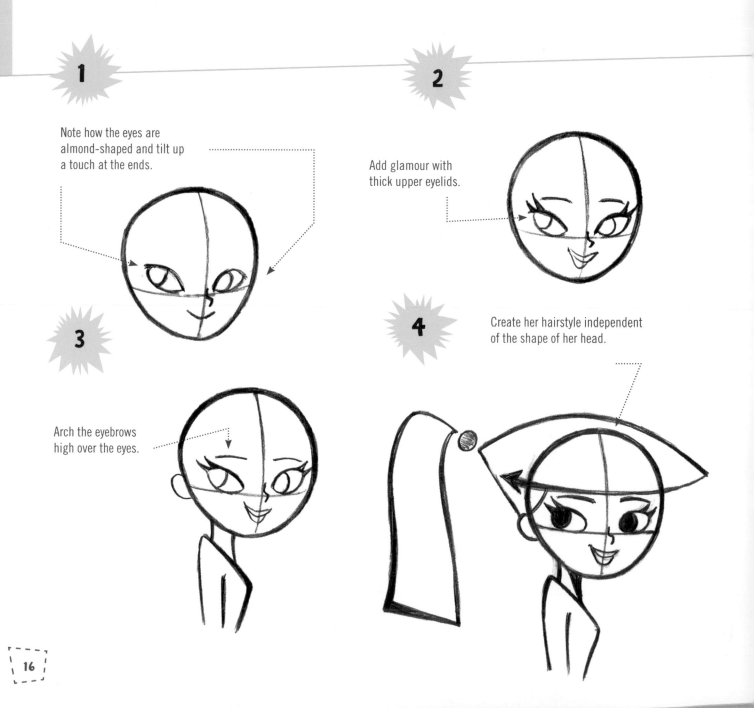

1

Note how the eyes are almond-shaped and tilt up a touch at the ends.

2

Add glamour with thick upper eyelids.

3

Arch the eyebrows high over the eyes.

4

Create her hairstyle independent of the shape of her head.

5

More is less. Drawing a pretty character like this is very achievable. But many aspiring artists attempt to do too much to create a pretty look. Simplicity is key. A few pretty features on an uncluttered face, combined with a good hairstyle, is all you need.

THE CIRCLE AT DIFFERENT ANGLES

THE CIRCLE IS AN EASY SHAPE TO TURN AT DIFFERENT ANGLES, BECAUSE THE SHAPE STAYS THE SAME. ALL YOU DO IS CHANGE THE PLACEMENT OF THE GUIDELINES.

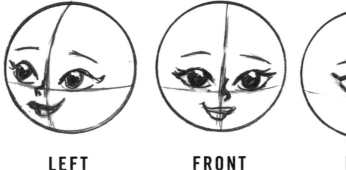

LEFT FRONT RIGHT

ROUND-HEAD ADULT

You don't usually see adult cartoon characters whose faces are completely round. But when you do, they often appear to be somewhat roly-poly. That's because older characters based on real people have eyes set high on their heads, which makes everything below the eyes appear to be made up of cheek fat and giant jowls.

Beards and facial hair on older adults are usually trim and neat. Note that the mouth is effectively hidden underneath the mustache—a cute device. And remember this immutable axiom—I call it the Law of Compensation—when designing funny adult characters: The less hair a guy has on the top of his head, the more hair he'll grow on his face. (This is also known as the Please Don't Notice My Baldness Maneuver.)

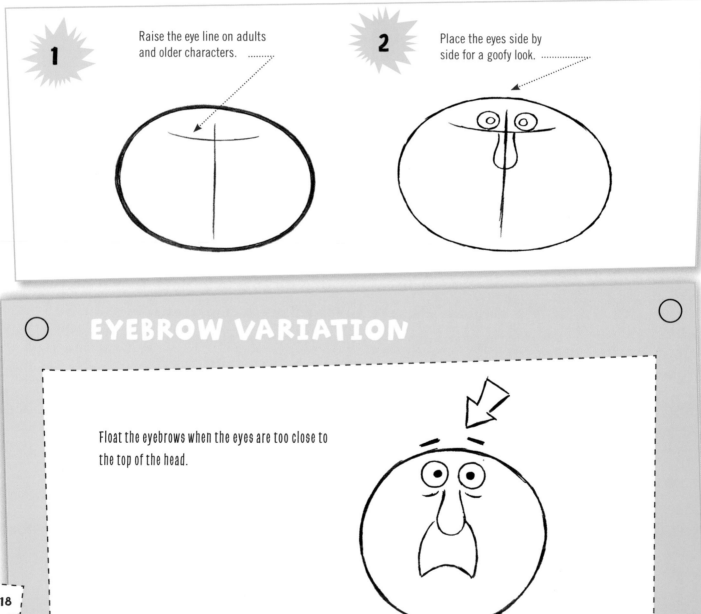

1 Raise the eye line on adults and older characters.

2 Place the eyes side by side for a goofy look.

EYEBROW VARIATION

Float the eyebrows when the eyes are too close to the top of the head.

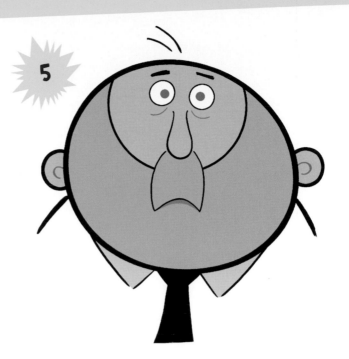

3

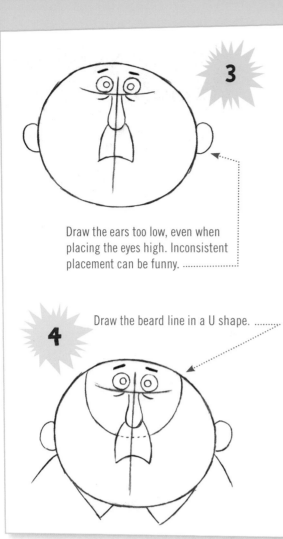

Draw the ears too low, even when placing the eyes high. Inconsistent placement can be funny.

4

Draw the beard line in a U shape.

Adjust the facial features on the head, raising or lowering them according to the age and personality. The ears, however, can stay fairly low at any age. If you're wondering whether it looks anatomically incorrect to draw ears so far below the eyes, the answer is: of course it looks anatomically incorrect! It's supposed to look incorrect. It's a cartoon. That's what makes it funny!

NECK LENGTH AND CHARACTER AGE

THE OLDER A CHARACTER, THE SHORTER THE NECK, UNTIL THE NECK IS ACTUALLY REMOVED.

See how awkward this senior citizen looks with a long neck.

Omit the neck for a funnier look.

FACIAL FEATURES

Up until this point, I've focused on showing you how to draw the outline of the face. Now, let's turn to the features, where the real fun starts . . . !

There are many types of features: eyes, noses, and mouths. And there are specific types of each, such as glamorous eyes or a mouth with a goofy underbite.

Some people say that that there is no "right" way or "wrong" way to draw the eyes, nose, and mouth. And they're correct. There's no right or wrong way to draw anything. But some ways not only look better, they are also more visually appealing to viewers. Which is another way of saying they're "popular." Then, there's the other way. Let's go with the popular ones.

THE EYES

There is a wide and popular range of eye shapes to choose from. You can also mix and match them to create your own combos. As you'll see, some eyes are a better fit for some characters than for others. This doesn't mean you can't add one eye type to a character that usually takes a different eye type. But if you do, be bold. Have fun creating something unexpected.

Give each of these eyes a practice draw to get the feel for it.

POPULAR EYE SHAPES -

CIRCLE

This is the most common eye shape. It can be used for almost any character.

TALL OVAL

This shape is almost as common as the circle. Note that the eye is oval, but the pupil remains a circle. It's often used in more humorous characters.

 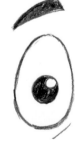 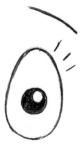

FLATTENED OVAL

Cartoonists often use this shape for droll characters, sarcastic characters, or somewhat low-class characters. Note that the pupil is also an oval but can be a dot as well.

 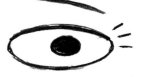

SEVERE

A large, horizontal oval, cut in half by a sharp eyelid, creates a funny, intense look.

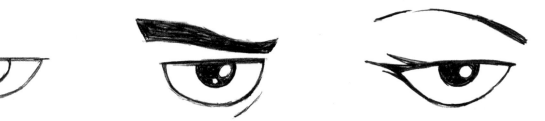

ALMOND

Note: This common eye type is for females only. You can tilt these eyes up at the ends to add a touch more femininity. Her top eyelid is always darker than the bottom, unless the character is spooky or weird. Using a glistening pupil and a hint of eye shadow adds glamour.

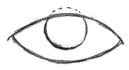 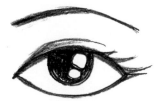

PRACTICAL APPLICATION ★

By adding the rest of the features to the eyes, you can see what a big impact the eyes have. They totally outshine the mouth—unless the mouth is used to create an extreme expression. You can tell what a character is *thinking* by his eyes. Eyebrows are not just an afterthought. They are the exclamation point that drives home the expression. From here, you'll work with a set of two eyes rather than detailing the shape of a single eye. (Don't worry about drawing the mouth yet, it's just here to help to clarify the concept. I'll cover mouths in a few pages.)

Before you give these examples a try, read the special tips on page 25, which are probably the most important developments about cartoon eyes in the whole book. Perhaps, they're the most important developments about anything ever, right up there with the development of antibiotics and spray cheese in a can!

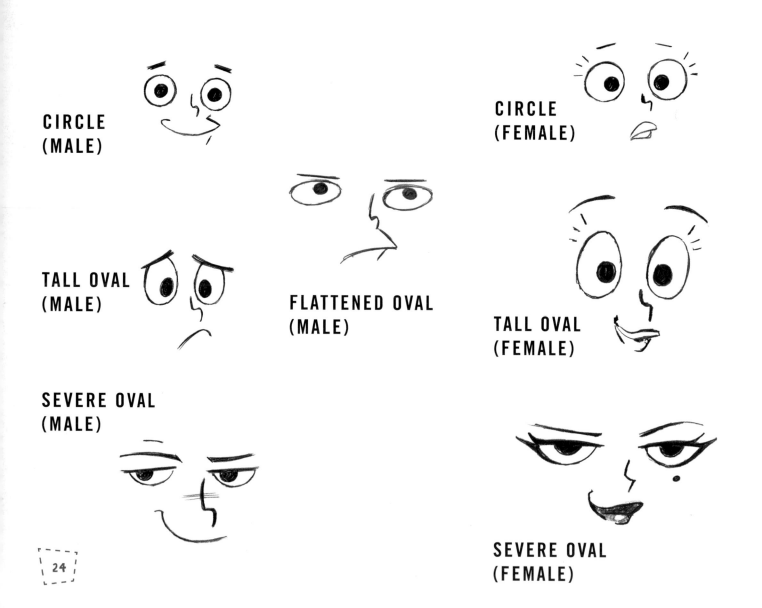

CIRCLE
(MALE)

CIRCLE
(FEMALE)

TALL OVAL
(MALE)

FLATTENED OVAL
(MALE)

TALL OVAL
(FEMALE)

SEVERE OVAL
(MALE)

SEVERE OVAL
(FEMALE)

THE TYPE OF EYE YOU DRAW (THAT IS, GENDER, AGE, OR EXPRESSION) IS NOT NEARLY AS IMPORTANT TO THE ULTIMATE SUCCESS OF THE DRAWING AS THE FOLLOWING FOUR GUIDELINES ON YOUR "I SHOULD REMEMBER THIS WHEN I'M TRYING TO DRAW CARTOON EYES" LIST. WITH THESE IN MIND, YOU CAN MOLD THE EYES INTO ANY SHAPE AND EXPRESSION YOU WANT.

1. Tilt: Both eyes need to tilt at the same angle (women's eyes, especially, tend to tilt up at the ends).

2. Shape and Symmetry: The shape of both eyes needs to be the same, unless an expression is forcing one eye into a different position.

3. Level: Both eyes MUST be drawn on the same level so that they don't appear to be lopsided! This is actually a fairly common problem among aspiring cartoonists—and so easy to solve. Simply begin your sketch by drawing a light eye line in your initial construction of the cartoon head. (This is why I include eye lines in all the step-by-step constructions.)

4. Equidistance: Both eyes need to be of equal distance from the nose and from the edge of the face on both sides.

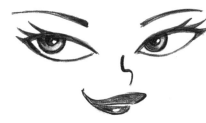

FLATTENED OVAL (FEMALE)

ALMOND (FEMALE ONLY)

THE PUPILS ---

Here's a highly effective, often overlooked technique for creating humorous cartoon eyes: adjust the pupil. By adjusting the size, placement, and shine of the pupil, you can change the look of the character. You don't believe me? That's nothing new. They laughed at me when I predicted the end of the earth. The fools!

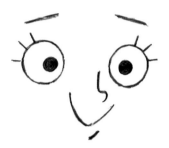

NORMAL-DOT PUPILS

Surround teeny dots with an ocean of white for funny-looking pupils.

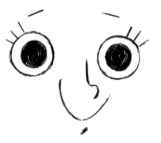

ENLARGED PUPILS

Pupils enlarge to show happiness, satisfaction, or joy. In fact, this is a biological reflex and scientifically accurate. For cartooning, increase this effect so that the pupils are *huge*.

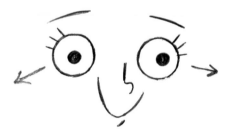

WANDERING-DOT PUPILS

Make the pupils diverge slightly, but not too much, for a humorous effect.

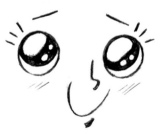

SUPER-DUPER GIANT PUPILS

Here the pupils are so enlarged that they take up more space within the eyeball than the whites do! The pupils also feature a constellation of shines of various sizes and shapes.

ADULT MEN AND DAD EYES

Grown-man eyes are funny in the way they depict a man, beaten down by years of dashed hopes and dreams. But in a good way. The top eyelids slope downward as they travel away from the nose. If you make the angle too steep, your character will look sad. And that's okay—if the character *is* sad. Otherwise—it is not. You can counter the sad look and still end up with dad eyes by drawing eyebrows without a sorrowful expression.

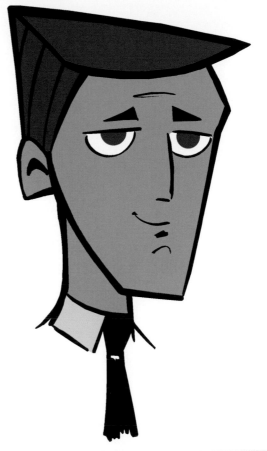

CLOSE-UP: NORMAL EYE VS. DAD EYE

NORMAL EYE
Bouncy and bright.

DAD EYE
Droll and fatigued.

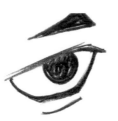

ATTRACTIVE FEMALE EYES ----------------------------------

What's the deal with the deer-in-the-headlights look? Well, that's what you get if you draw heavily made-up female eyes.

Here's how to adjust the eyes so that they look appealing, even harmlessly seductive. Lower the top eyelid on the pupil, cutting it off at the top. This will also cause the overall shape of the eyes to narrow and become more severe.

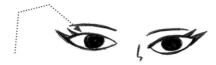

Notice how the top eyelid doesn't cover enough of the eyeball.

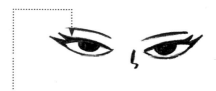

See how the top eyelid covers the top third of the eyeball and the eyelid is much thicker? This gives her eyes a heavy look.

CLOSED EYES --

It may surprise you to learn that closed eyes are among the most frequently drawn eye positions in cartoons. They add variety and pacing, and simply look funny. And the best thing of all: They're a breeze to draw. I've almost been able to teach Rusty, my evil Welsh springer spaniel, how to draw them. And I believe he could do it, too, but the whole "lack of thumbs" stuff gets in his way.

Notice all the different meanings that can be achieved with closed eyes.

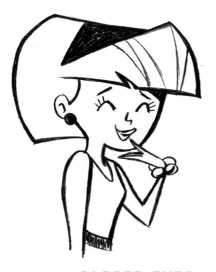

CLOSED EYES
"UP"—HAPPY

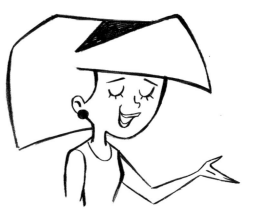

CLOSED EYES
"DOWN"—CONFIDENT

OTHER EXAMPLES OF CLOSED EYES

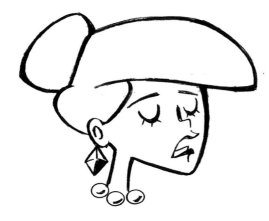

SNOBBY

CRYING BUCKETS

ANGER

PAIN

Here's a common problem for cartoonists: You want to draw your character in a front view, but you designed him with a nose that points in one direction. In the front position, the nose faces directly forward, not left or right. This flattens the nose. But you've created a character with a pointy nose, which simply looks wrong in the front view. By drawing the nose in the front view, in real perspective, you may end up with an accurate picture, but it won't be fun.

Should you give up, move to a mining state, and dig for coal instead of draw? No! I don't like to rule out any options, but I see no reason for panic. You came here to learn how to draw cartoons, and by God, I am going to teach you how to do it.

Here's the solution: *Cheat*. Yes, you read correctly. When you draw a front view of the head, keep all other features in a front view but use a side view for the nose. Toss out the front-view nose completely—don't use it. Not only will this approach make your character look consistent, but it will increase the funniness quotient. I know, some of you hate the sound of the word "cheat." But you have to ask yourself: Do you want your integrity, or are you looking for a quick fix to life's problems? Me too! Go with the "cheating" technique.

FRONT VIEW—NOSE POINTS FRONT
This method flattens out the nose. But it isn't appealing and changes the look of the character.

FRONT VIEW—NOSE POINTS LEFT

Here the head remains in the same front view, but the nose is drawn in a side view.

FRONT VIEW—NOSE POINTS RIGHT

This front-view pose features an angular nose pointing right. The nose retains its funny pointy look.

THE MOUTH

What, exactly, is a "mouth," from a cartoonist's point of view? Is it a frown? Or a laugh? The truth is that there is no single mouth position to learn how to draw. Instead, there are many mouth positions. And the only way to learn how to draw them is . . . to draw them!

In this section, I'll cover a plethora of mouth positions. (That thesaurus really came in handy.) These are the most popular mouths. Some are basic. Others are extreme. You don't have to follow my instructions slavishly. Just start drawing. If you end up with a mouth that looks different from mine but works, then use it!

Let's start with the 3/4 view, which is the angle that most commonly appears in cartoons. Then I'll show you how to draw the mouth in profile.

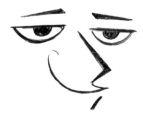

WIDE SMILE
The smile rises up, almost to the eye.

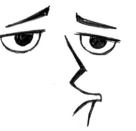

PUSHED-OUT POUT
Overlap the top lip here.

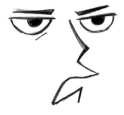

OPEN-MOUTH ANGER
In this configuration, the top and bottom lips are uneven.

OPEN-MOUTH SMILE
The more teeth you show, the more intense the laughter looks.

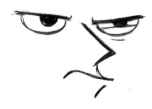

PEEVED
Push up on the lower eyelids, but only on one of them.

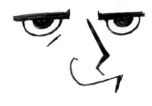

BIG-JAW SMILE

Even a weak-kneed character can suddenly assume this versatile mouth position: a ruddy jaw expressing supreme confidence.

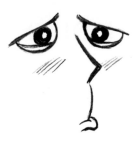

ABOUT TO CRY

Note how the line above the upper lip lengthens threefold.

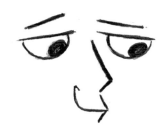

SUBTLE SMILE

To achieve this effect, clamp the top and bottom lips together tightly.

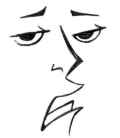

BOTTOM TEETH ONLY

Note how the bottom lip drags the mouth way down at the end.

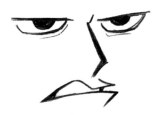

DETERMINED ANGER

Here the lips remain strongly horizontal.

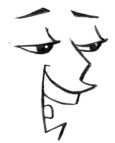

JOVIAL SMILE

Note the minimizing of the lower lip.

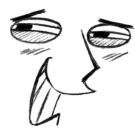

FALSE SMILE

Crush the eyeballs between cheesy, half-closed eyes.

HUMOROUS MOUTH POSITIONS: SIDE VIEW - - - - - - -

Using your imagination to devise new and fresh mouth types is a great way to enhance the entertainment value of your character and keep yourself from dying of boredom at family reunions. But there's an easier way to go about it.

Before attempting all of the mouth positions, randomly try the basic four below. These will help ease you into the more advanced mouth positions on the following page.

OVERBITE

INSECURE
Use this position for a typical look, stare, or reaction.

CONFIDENT
This variation creates a sly smile.

UNDERBITE

ROCK STEADY

EMOTIONAL
This position creates a prideful look.

STRETCH

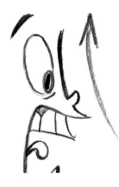

BIG STRETCH—SHOCKED

Stretch the edge of the profile along a
curved line.

LITTLE STRETCH—SNEAKY

Grow more teeth!

CRUNCH

BIG CRUNCH

Here you can see insane anger.
Everything clamps down toward the nose.

LITTLE CRUNCH

This variation demonstrates impatience
combined with annoyance. I used to see
this look all the time on my dad's face.

WARPING

BIG WARPING

The profile is drawn on a diagonal.

LITTLE WARPING

The forehead is vertical, but the rest of
the face is straight.

FEMALE LIPS

Creating female lips is about more than simply adding thickness. The nuanced way that they curve and the ways in which they come together to form a smile add to the character's femininity. The length and width of a smile also make a huge difference in their appeal. An important point to keep in mind: Attractive female characters' lips and mouths are more attractive if they are not making broad expressions but instead make petite ones.

CLASSIC VERSION

Both lips curve upward, with the bottom lip the thickest of the two.

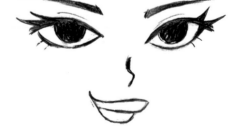

BOTOX VERSION

The top lip overlaps the bottom one, and the smile occurs on one side only.

VARIATION

Here the top lip is fairly straight, but thickens, rather than dips, in the middle.

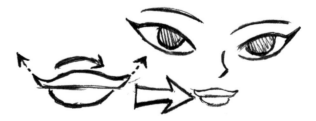

FEMALE SMILE

We usually think of smiles as rising upward on the face. But oh the price we pay for the assumptions we make! On pretty feminine characters, the top lip is horizontal and even curves slightly downward. I can hear your gasps: "I've been . . . wrong all this time. But I was so sure . . . What else have I been wrong about?" Probably a lot. But let's not get off track.

For this type of smile to work best, it should be both wide and deep. The lips thin out when stretched but maintain most of their thickness in the middle.

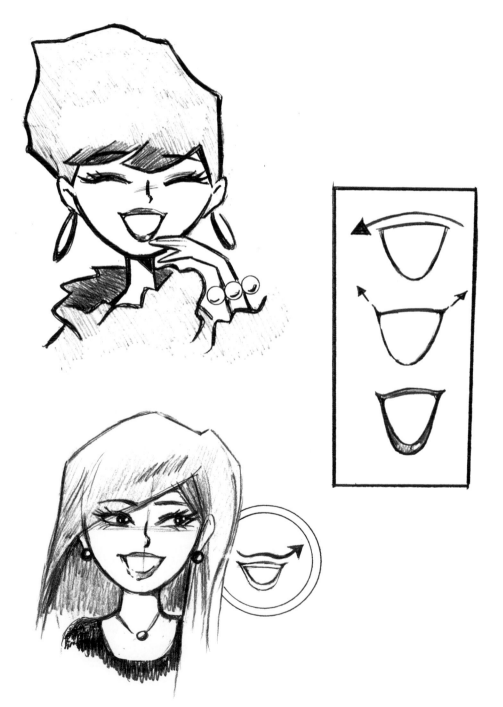

The top lip is straight or curves slightly downward.

The tiny smile creases at the ends curl upward.

Add thickness to the lips.

IT'S OFTEN FUNNIER IF YOU TAKE A "NORMAL" MOUTH POSITION, LIKE THIS DOWNTURNED ONE, AND INSTEAD PRESS THE LIPS TOGETHER AND PULL THEM TO ONE SIDE.

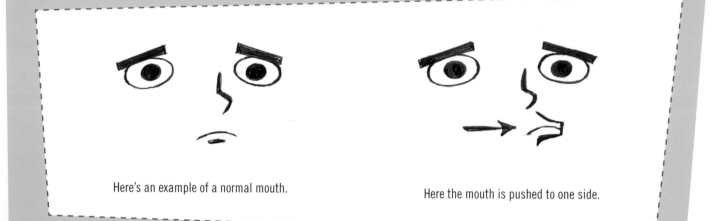

Here's an example of a normal mouth.

Here the mouth is pushed to one side.

THE EYES AND MOUTH WORKING TOGETHER

Whether eyes or mouths are most effective in creating an expression is something that may remain a mystery forever, like the pyramids and when a magician pours water into a rolled-up newspaper. Most effective of all is when the eyes and mouth work together in a cartoon. It's like that famous saying: The eyes may be the windows to the soul, but the mouth is the doorway to the stomach. Or something like that.

Now I'll show you how to draw the eyes and mouth on the guidelines so that no matter how exaggerated the expression may become, you'll maintain the symmetry of the face.

By observing these examples, you can see just how important using guidelines are for drawing the face. Each expression on this page pushes and pulls the various features. But the guidelines keep everything in alignment. Think of the guidelines as your stability bars for drawing faces.

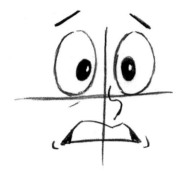

TREMBLING

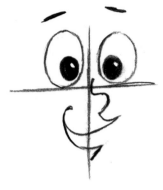

HAPPY

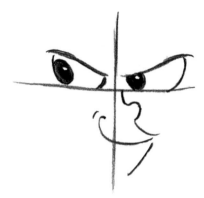

WICKED

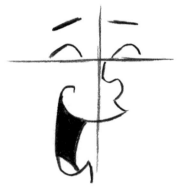

LAUGHING

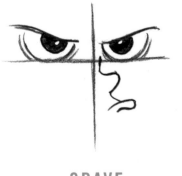

GRAVE

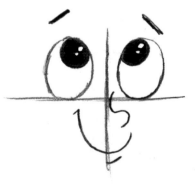

WHIMSICAL

CHAPTER

3

MOVING BEYOND THE BASIC
HEAD SHAPE

To develop a variety of cartoon characters for any reason—whether it is to create a portfolio, a graphic novel, webcomics, or animation—you will need to be able to show a variety of characters, some basic and some advanced. This will keep the viewer interested and involved. But by what method do you accomplish this feat? Can anyone guess how to accomplish this? Anyone want to offer a guess as to what that is? You, in the back row?

Right answer: Move past the basic circle and include other head shapes. A circle is a great foundation shape, but it can also be limiting, because the circle does not allow you to place more emphasis on one part of the face over another—it's equal in all directions. Limiting yourself to only one head shape risks monotony in your cast of characters.

SMALL CHANGES— BIG RESULTS

Let's establish a circle-based head, and then show what happens when you tweak the shape. All shapes are pliable in cartoons. Adjust the shape of the head, and in the process, you can create very different looks for this character. This character is attractive, therefore she'll need a new head shape to retain her soft look.

STYLISH GIRL --

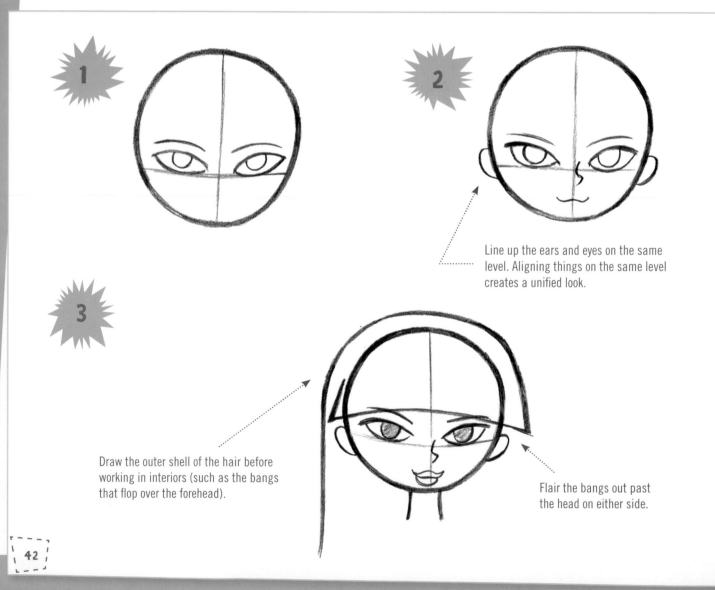

Line up the ears and eyes on the same level. Aligning things on the same level creates a unified look.

Draw the outer shell of the hair before working in interiors (such as the bangs that flop over the forehead).

Flair the bangs out past the head on either side.

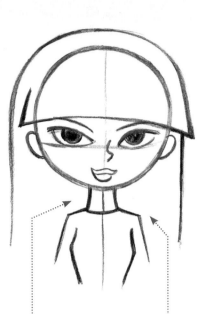

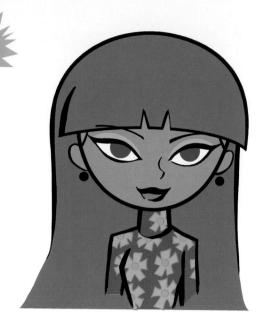

Give her a ridiculously thin neck . . .

. . . and pair it with ridiculously thin shoulders, as well.

You can dangle her earrings any way you wish, but give these "floating" earrings a try. It's humorous without taking anything away from the character's attractiveness.

NARROWING THE JAW ------------------------------

You can modify the circle so that it is sleeker or fatter. Let's studiously examine each approach.

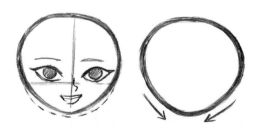

To create a more feminine face, take the circular outline and narrow the jaw area so that it tapers just a little.

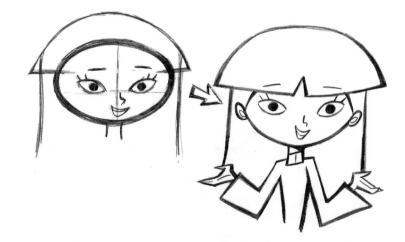

Leaving the circle behind, take this same character and fit her with an oval-shaped head. Immediately she becomes quirkier—and funnier, too.

THE EGG-SHAPED HEAD -------------------------

Another very popular head shape is the egg. The upside-down egg shape creates a large forehead but a slender jawline. While the circle is perfectly suited to younger kids and some female teens, the egg shape has a wider range of possibilities. It works well as the foundation for male and female teens, adults, and even some kids.

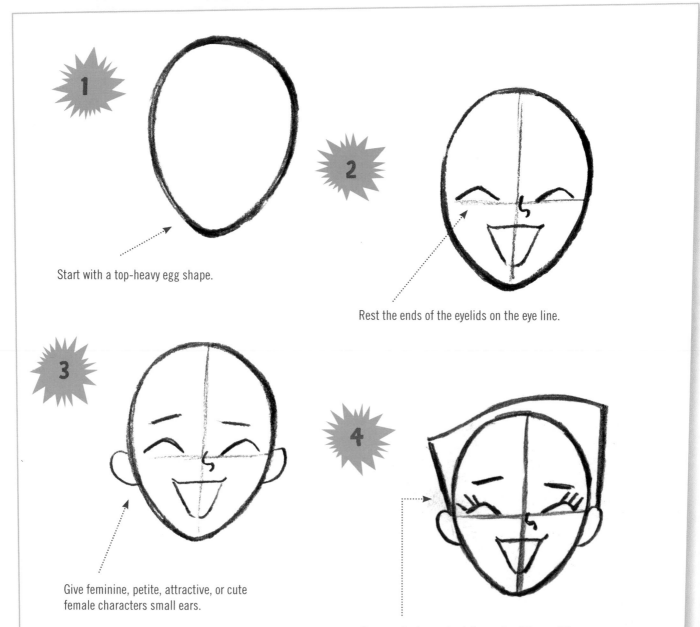

Start with a top-heavy egg shape.

Rest the ends of the eyelids on the eye line.

Give feminine, petite, attractive, or cute female characters small ears.

Draw eyelashes only at the ends of the eyelids.

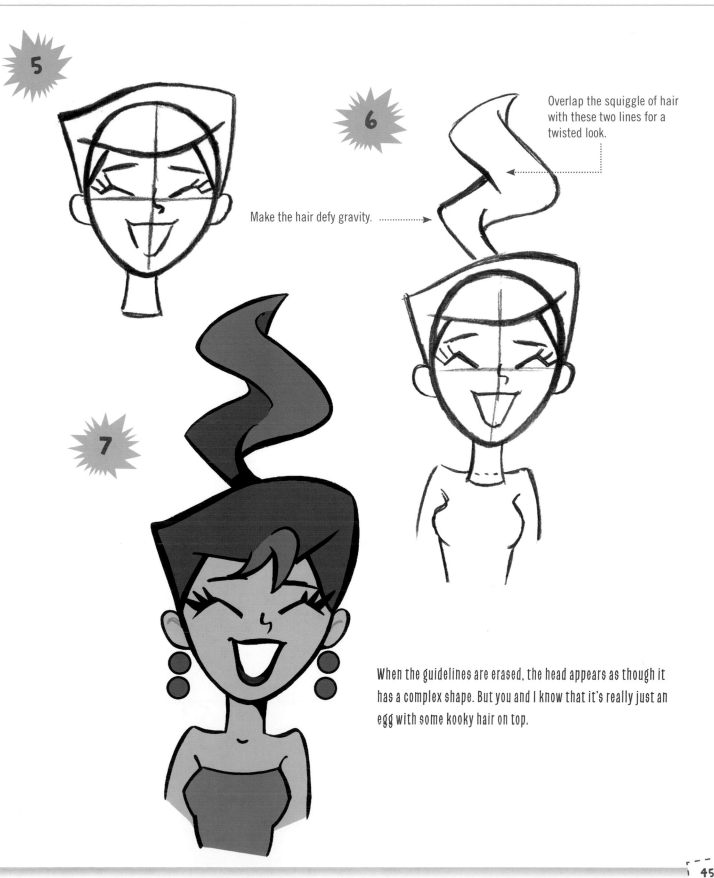

5

6

Make the hair defy gravity.▶

Overlap the squiggle of hair with these two lines for a twisted look.

7

When the guidelines are erased, the head appears as though it has a complex shape. But you and I know that it's really just an egg with some kooky hair on top.

THIN FACES

In cartooning, every shape can be adapted to create a new character. This elongated egg shape works best on teens and young adults because the face tends to thin out as a person ages. It also hooks up well to a skinny neck.

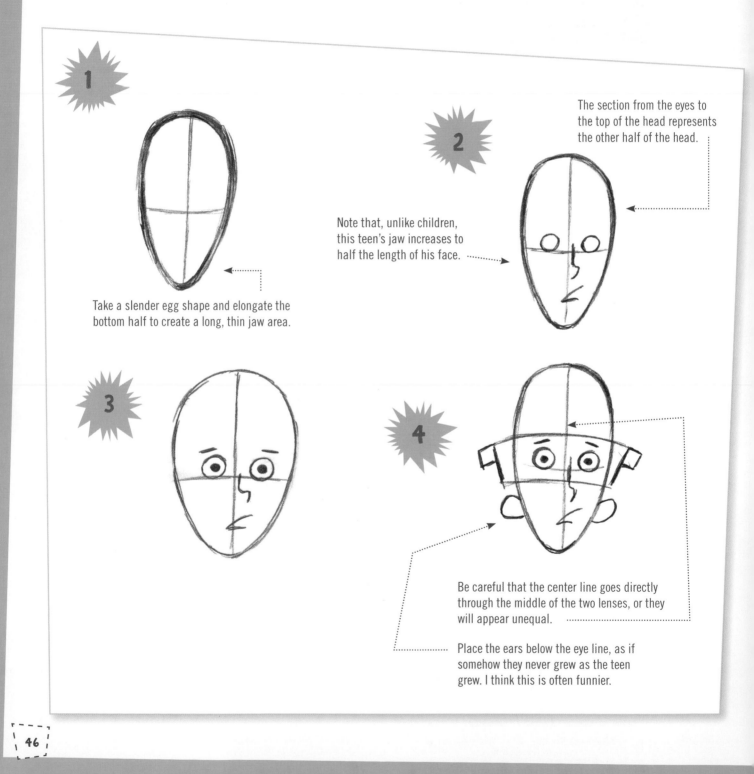

1

Take a slender egg shape and elongate the bottom half to create a long, thin jaw area.

2

The section from the eyes to the top of the head represents the other half of the head.

Note that, unlike children, this teen's jaw increases to half the length of his face.

3

4

Be careful that the center line goes directly through the middle of the two lenses, or they will appear unequal.

Place the ears below the eye line, as if somehow they never grew as the teen grew. I think this is often funnier.

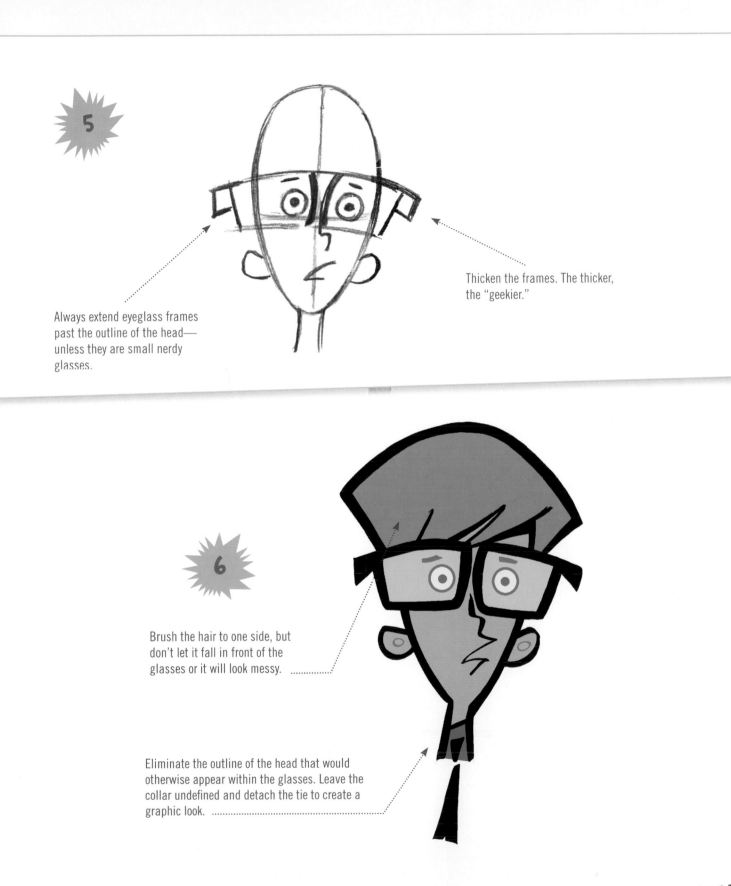

5

Always extend eyeglass frames past the outline of the head—unless they are small nerdy glasses.

Thicken the frames. The thicker, the "geekier."

6

Brush the hair to one side, but don't let it fall in front of the glasses or it will look messy.

Eliminate the outline of the head that would otherwise appear within the glasses. Leave the collar undefined and detach the tie to create a graphic look.

THE CLASSIC CARTOON HEAD SHAPE

This, my friends, is the mother of all cartoon head shapes. This is the Big Kahuna, the demigod that rules over everything that is art—except for cubism. What the heck is with that stuff anyway?

This popular head shape has been around since the dawn of cartooning and even before. In fact, if you look through cave paintings, you'll actually see that Cro-Magnon man represented himself in art with roughly this type of head shape. In perhaps the most well-known image, Cro-Magnon man is seen getting a sudden burst of inspiration with a very primitive lightbulb painted over his head.

Fast-forward to the present, and you can see this same head shape in use all over TV and movie animation. This shape features a pudgy cheek that sticks out on one side only, which can make cute characters even cuter. The same construction also works for adult characters, where the cheekbone is made to look bonier instead of soft and chubby. And this classic head shape also allows the forehead to slope either backward or forward, depending on the look of the individual character.

CUTE BOY

This is quite simply the most versatile cartoon head shape of them all. Don't believe me? Just look at this example!

1

Start with a circle (once again, it doesn't have to be a perfect circle).

2

Carve out an inward (concave) curve to the forehead, bringing it all the way down to the bottom of the face. Just before you reach the bottom, make the curve jut out and return to the chin.

3

Look: the classic head shape.

4

The cheek can be drawn low on the face.

5

The simple jag-step of the outline remains the same whether the cheek appears extremely low (kids), slightly lower than halfway down (teens), or in the middle of the face (adults).

6

The pushed-out cheek really adds something to the look of the face, which is why it is incorporated into so many characters' head shapes.

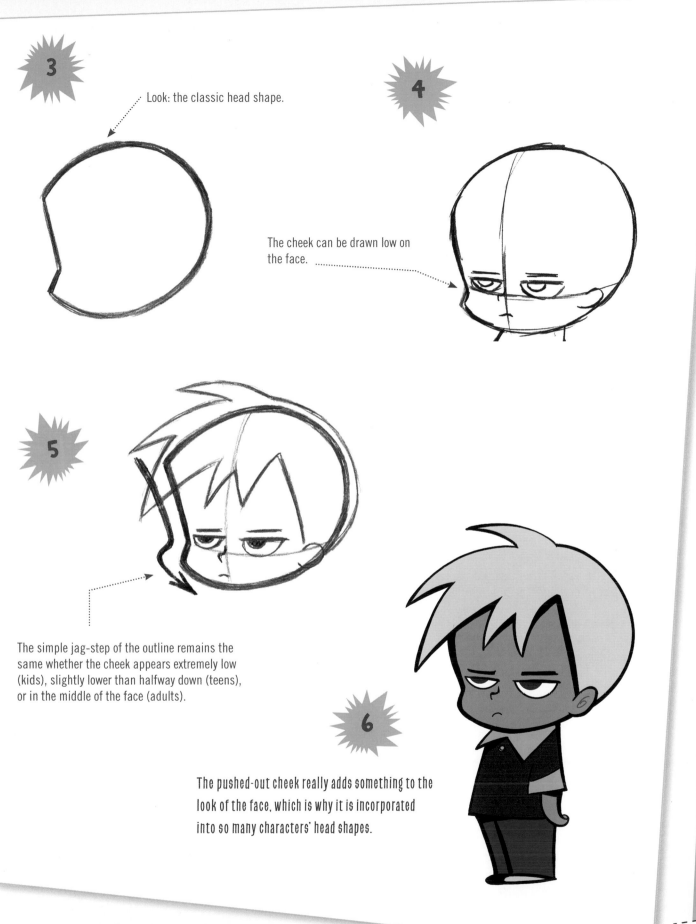

CUTE GIRL

The chin is tapered on the female character in this classic cartoon construction. Many aspiring cartoonists believe that in order to draw cartoon girls, they must treat the character with only subtle and soft curves. Well, this isn't true. I don't know who has been filling your head with these lies, but if I ever catch that guy, why I'll . . . I'll . . .

Sorry, it's just that I get so passionate about cartooning.

The point is that cute-girl cartoons have sudden, abrupt shifts in the angles of their heads, which cause the cheeks to stick out and, sometimes, even look pointed!

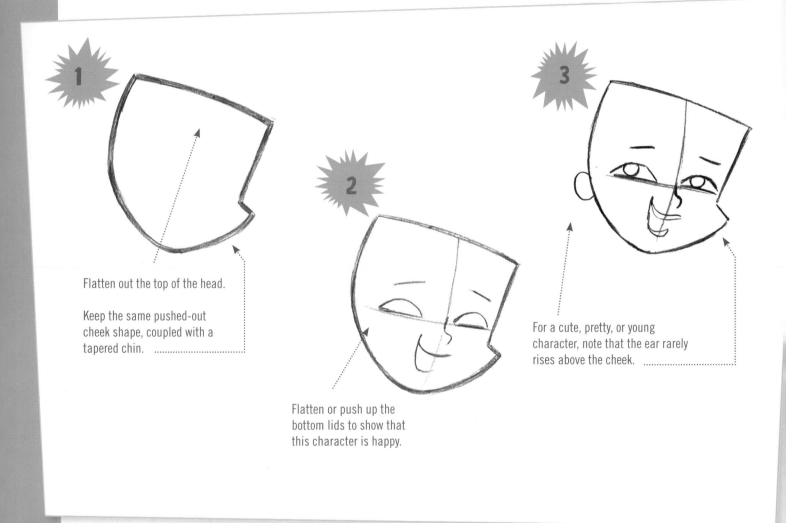

Flatten out the top of the head.

Keep the same pushed-out cheek shape, coupled with a tapered chin.

Flatten or push up the bottom lids to show that this character is happy.

For a cute, pretty, or young character, note that the ear rarely rises above the cheek.

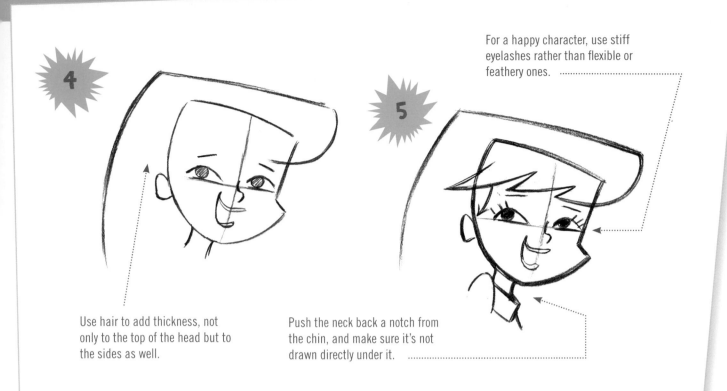

4

Use hair to add thickness, not only to the top of the head but to the sides as well.

5

For a happy character, use stiff eyelashes rather than flexible or feathery ones.

Push the neck back a notch from the chin, and make sure it's not drawn directly under it.

6

How about an oversized earring and some sharp bangs, brushed back, to give her a little flair? Do the earrings attach to the earlobes? Nope! They defy physics. Antigravity earrings are great for day wear.

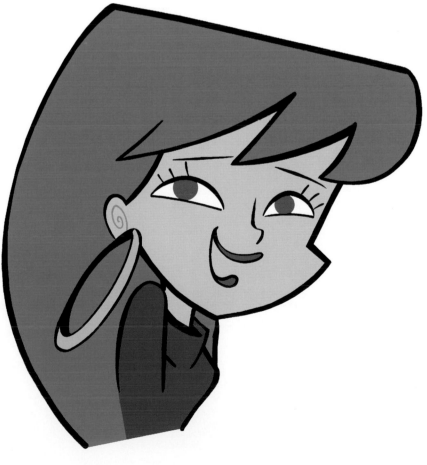

GIANT FOREHEADS

Some aspiring artists come up to me at comic or manga conventions to show me their portfolios. It's a great honor and is one of the things I enjoy most about being a cartoonist. And because of this, I've been able to notice common themes in their work. Often a cartoon character is depicted with a distorted head shape in order to depict a huge emotion like yelling, then when the character stops screaming, the artist draws the head shape in a more subdued and traditional way. But you're allowed to draw the character in a semi-distorted manner as part of his or her basic character design. Notice how misshapen this know-it-all's head is (too much brains for his own good), whether or not his expression is extreme.

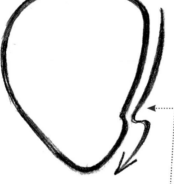

Use a huge forehead for smart characters, or for evil characters who like to think of themselves as smart.

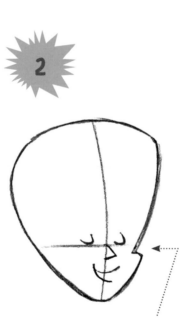

Tilt these closed eyes with attitude forward—it makes a subtle but noticeable difference.

Make the round, nerdy glasses small enough to fit inside the head.

Notice how the arms of the eyeglass frames don't even touch the ears. Why even use them? *Because* they're useless—which is funny!

Cover a bit of the chin with a turtleneck.

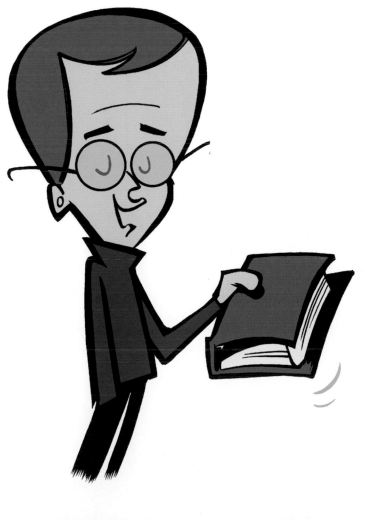

With a head this big, there's no need to build out the hair, which would add too much volume. Note how the hair is drawn *within* the head shape, not on top of it, for a funny look.

TURNING UNUSUAL SHAPES INTO THE CLASSIC HEAD SHAPE

You can adjust almost any shape so that it becomes a version of the classic cartoon head shape. But why would someone want to make the classic head shape from something other than a circle? By starting with a different head shape, such as this weird, tall, rectangular oddity, you can end up with an edgier look for your final character. It's a great method for keeping your cartoons looking fresh and cutting-edge.

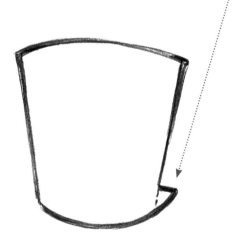

This shape is based on a modified square. Or maybe a rectangle. Although, it could be a rhomboid. But I don't know what a rhomboid is. The point is—it doesn't have to be an established geometric form. Any funny shape will work!

Notice that even a hint of the angular cheek turns an undefined shape into the classic cartoon head.

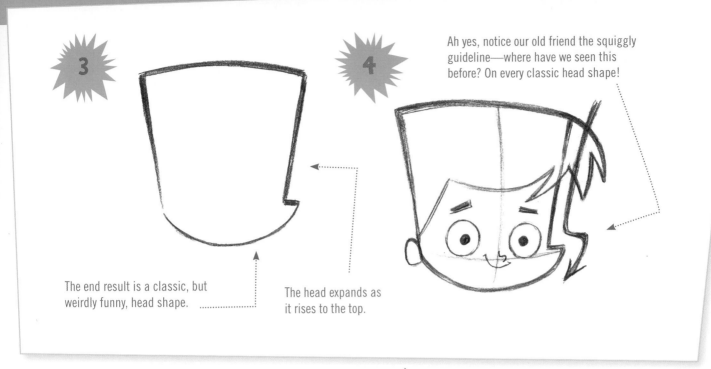

3

The end result is a classic, but weirdly funny, head shape.

The head expands as it rises to the top.

4

Ah yes, notice our old friend the squiggly guideline—where have we seen this before? On every classic head shape!

5

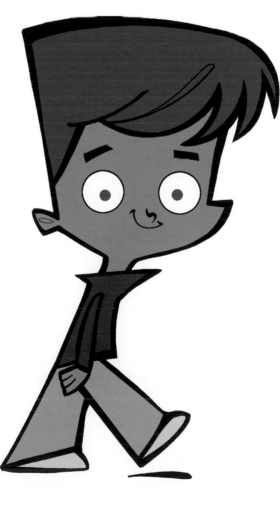

Don't—repeat—don't try to soften these angular lines. It takes away from his edgy look.

SCULPTING THE HEAD SHAPE

Now, on to cartoon "sculpting." This is a very effective and creative technique, which I developed, named, and protect with armed guards. Sometimes aspiring artists ask me if I really draw the way that I show others. This technique, which I will demonstrate, is *precisely* the technique I use all the time in creating new characters. And now you can, too.

What is the difference between a sculptor and a cartoonist? The similarities are surprising: Whether creating a bust of a person or drawing a cartoon head, both artists add mass to some areas and slice it away from others in order to refine the look. But the sculptor, generally, doesn't know any good jokes.

I'll show you how to sculpt using a pencil, by making small adjustments to the head.

STARTING POINTS—THE TALL OVAL

In order to sculpt something, you've got to start somewhere. An oval-shaped head is a good place to begin. By adding some mass here and an angle there, you can give him a decidedly sharper look, which results in a livelier character design.

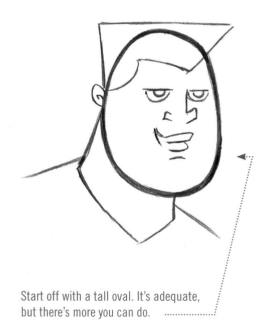

Start off with a tall oval. It's adequate, but there's more you can do.

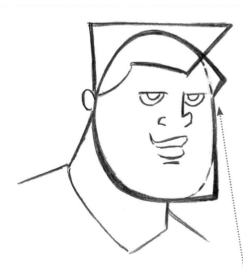

Add mass to the brow of the forehead and to the chin. Make both additions sharp instead of rounded to make the character appear edgy.

The character looks complicated, but he's not. You now know that all it takes is a basic foundation shape and one or two additional areas added onto it. Thank you for the applause. Really. Oh, it's too much. Seriously though, Mom, cut it out!

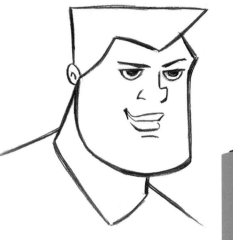

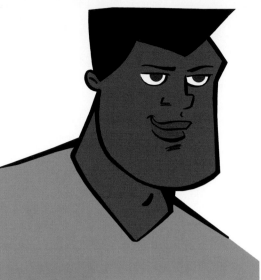

AVOIDING EXCESS COMPLEXITY

I USED TO THINK THAT YOU COULD ONLY CREATE COOL CARTOONS IF YOU USED A LOT OF DIFFERENT ANGLES FOR THE HEAD. WHAT A MISGUIDED YOUTH I WAS! ACTUALLY, I SOON FOUND OUT THAT MANY THINGS I BELIEVED WERE NOT TRUE: TOO MANY ANGLES DETRACT FROM THE LOOK OF A CARTOON.

I. Notice the four different planes of this guy's head. He looks sharp but also pleasingly straightforward.

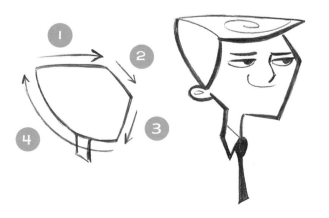

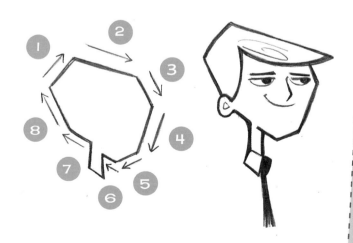

2. With eight planes to his head, this version of the same guy is unnecessarily complicated without adding much bang for your buck.

SCULPTING THE FOREHEAD ------------------------------

Do not try this on your friends at home. It should only be done to cartoon characters, who don't actually have any say. The forehead is an important part of the basic construction of the head. Many people draw it as a straight line. But it takes on a little more attitude if the forehead is drawn bulging out (convex) or bulging in (concave).

CONVEX

Notice that I've drawn past the outline in order to make sure the line curves at the same rate throughout.

CONCAVE

Again, extend the line past the head to make sure you've got the flow working in your favor.

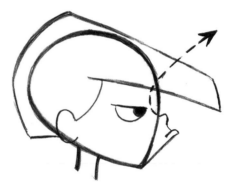

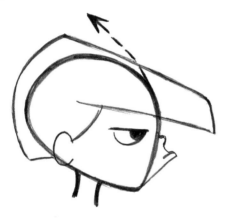

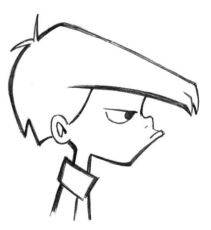

SCULPTING AND EXPERIMENTING

Experimenting is part of drawing. It's the way we develop something new. If there were only one way to do everything, it would be boring.

In this section, I'll show you how to use a variety of shapes and approaches so that you don't have to always start from the same mold. You can adjust the underlying foundation in order to get more individuality from your characters.

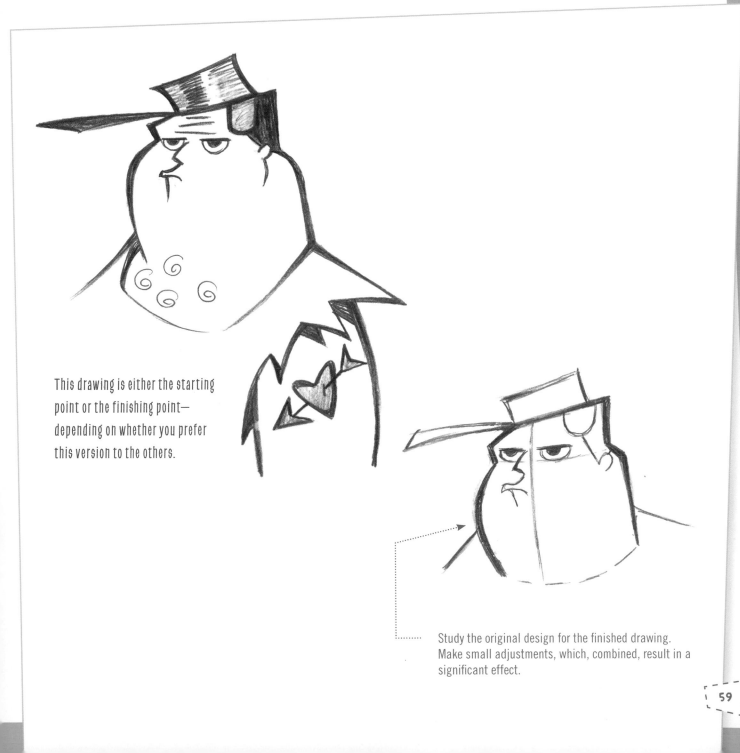

This drawing is either the starting point or the finishing point—depending on whether you prefer this version to the others.

Study the original design for the finished drawing. Make small adjustments, which, combined, result in a significant effect.

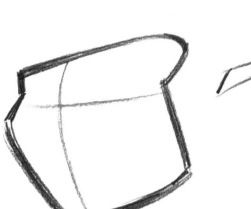

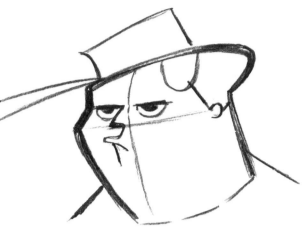

Here is the same guy, but with his chin buried in the neck.
Be sure to add a lot of "under-flub," just below the chin area.

Sharpen the cheek area. ··········▶ 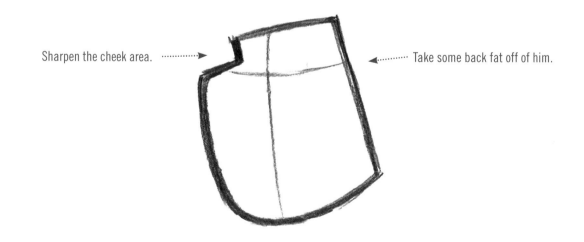 ◀·········· Take some back fat off of him.

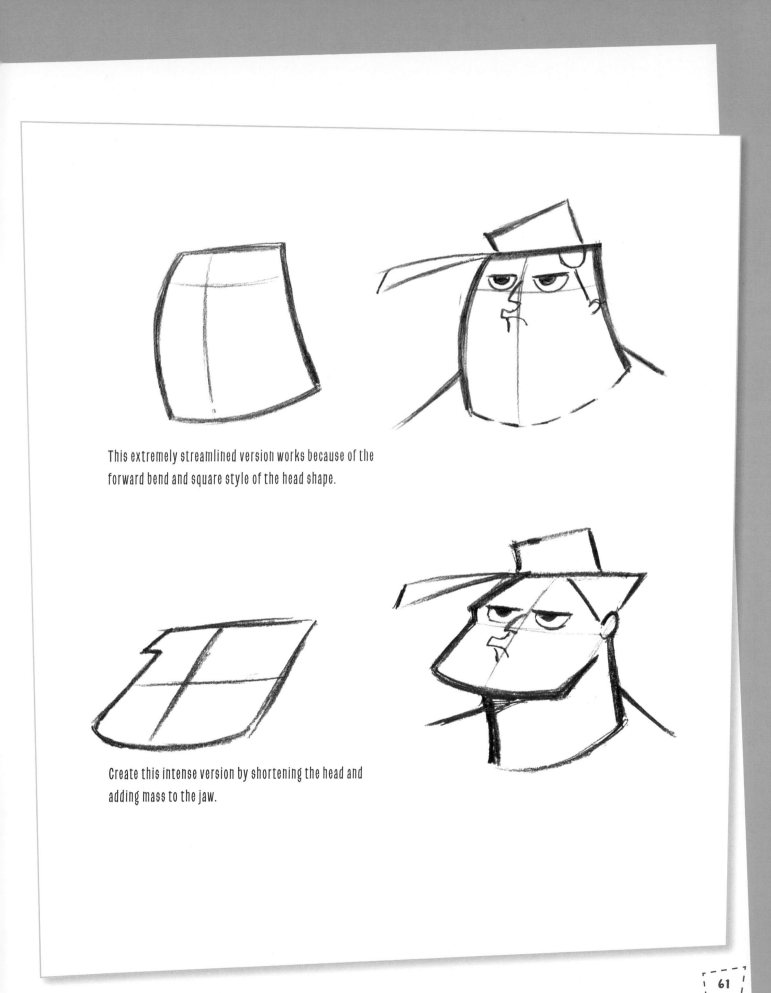

This extremely streamlined version works because of the forward bend and square style of the head shape.

Create this intense version by shortening the head and adding mass to the jaw.

Once you're familiar with the idea of sculpting a character in order to create a unique look, you're ready to give sketching a try. Sketch quickly and use bold lines without worrying about mistakes. You don't have to erase. You can be sloppy. I give you permission. You can tell your mom your room needs to be messy in order to draw correctly. Really run with this excuse.

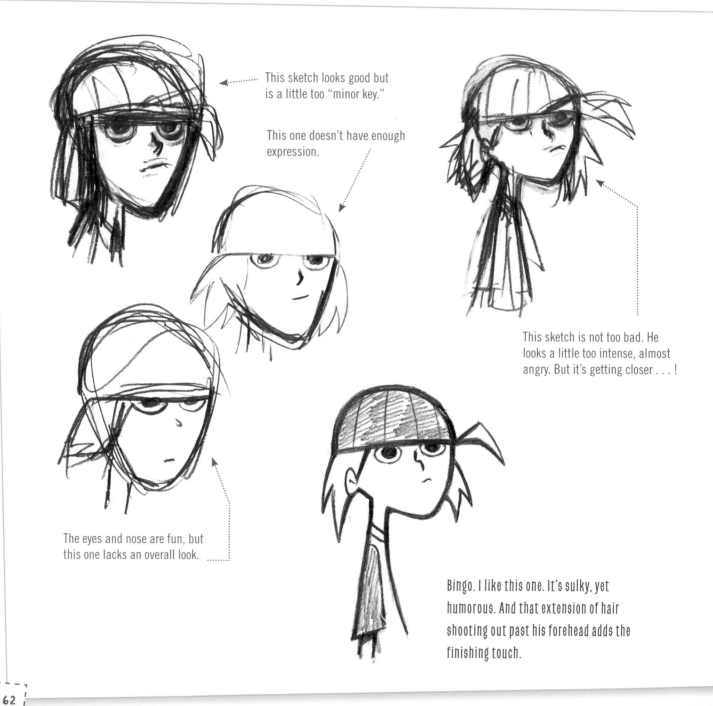

This sketch looks good but is a little too "minor key."

This one doesn't have enough expression.

This sketch is not too bad. He looks a little too intense, almost angry. But it's getting closer . . . !

The eyes and nose are fun, but this one lacks an overall look.

Bingo. I like this one. It's sulky, yet humorous. And that extension of hair shooting out past his forehead adds the finishing touch.

ADDING EXTREME VISUAL EFFECTS

Once you have your character designed as you want him or her—or it—then you'll want to add some expressions; but don't stop there. This is a cartoon! Go overboard. It's allowed. Don't keep a lid on it. Don't reel it in. Don't worry that you'll get so nuts that you'll have to take it back and apologize later. Allow yourself to put anything down on paper, short of a ransom note. And one very effective way to show energetic characters with added impact is to add visual effects to them. Here are just a few popular examples.

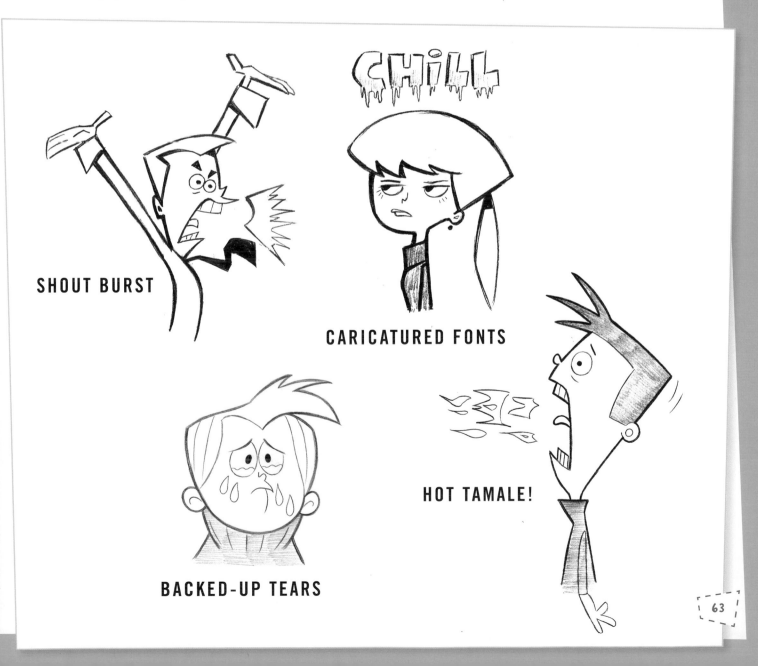

SHOUT BURST

CARICATURED FONTS

HOT TAMALE!

BACKED-UP TEARS

CHAPTER

4

MEDIUM SHOTS: THE BEST, MOST OVERLOOKED ANGLE

Oh it's sad—sad, sad, sad. So many aspiring cartoonists simply don't know that the medium shot is available to them as a great alternative to the close-up or full-figure shot. Medium shots are a great tool that allows the viewer to see the character close-up while also showing some of the body, which helps to establish more of the character's identity.

But the medium shot is more than simply a combination of two popular angles. It can be framed from the head down to the knees, or from the head to the waist, or at mid-chest. This angle allows you to get your feet wet before learning how to draw full figures. As you draw, using the steps and examples in this section, try to notice that the body and head must have a consistent look. For example, if a girl's face is pretty, then her body must also be attractive. If a guy's hair is slovenly, then his attire will be casual and somewhat messy. Because the medium shot is still relatively close-up, it's important to draw the outfits with care and detail.

PRETTY TEEN WITH FUNNY HAT

This pretty girl is wearing a hat derived from the popular manga style of Kawaii. Kawaii cartoons are famous for their cuteness. The eyes take up most of the room on the face. And here's a good touch for you to try: Draw the shoulders sloping slightly up, instead of down. Her body is well-shaped but fairly thin. This contrast makes her head appear larger and emphasizes her youth, making her look even cuter.

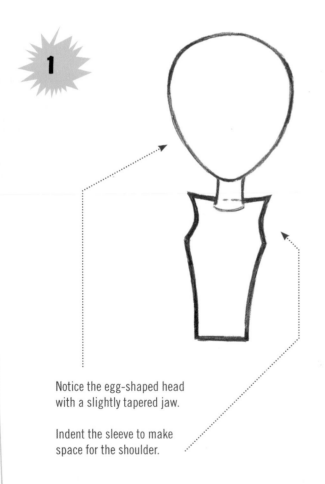

Notice the egg-shaped head with a slightly tapered jaw.

Indent the sleeve to make space for the shoulder.

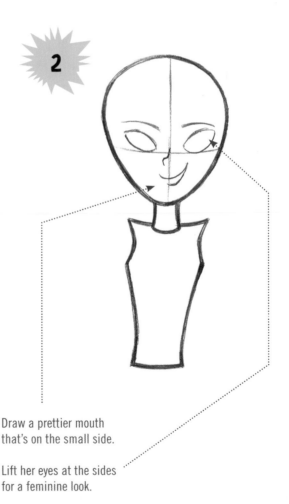

Draw a prettier mouth that's on the small side.

Lift her eyes at the sides for a feminine look.

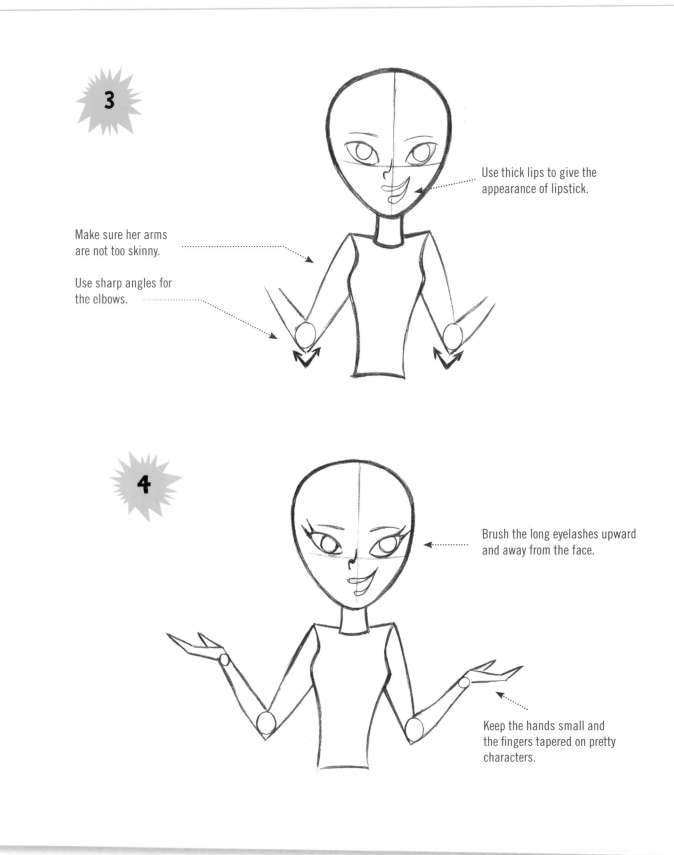

3

Use thick lips to give the appearance of lipstick.

Make sure her arms are not too skinny.

Use sharp angles for the elbows.

4

Brush the long eyelashes upward and away from the face.

Keep the hands small and the fingers tapered on pretty characters.

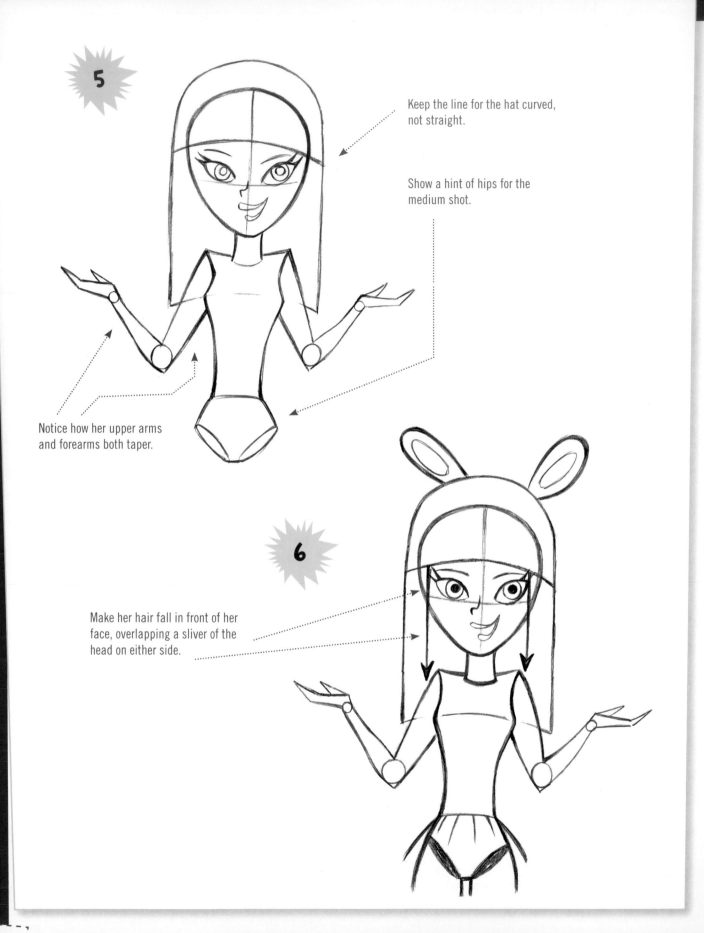

5

Keep the line for the hat curved, not straight.

Show a hint of hips for the medium shot.

Notice how her upper arms and forearms both taper.

6

Make her hair fall in front of her face, overlapping a sliver of the head on either side.

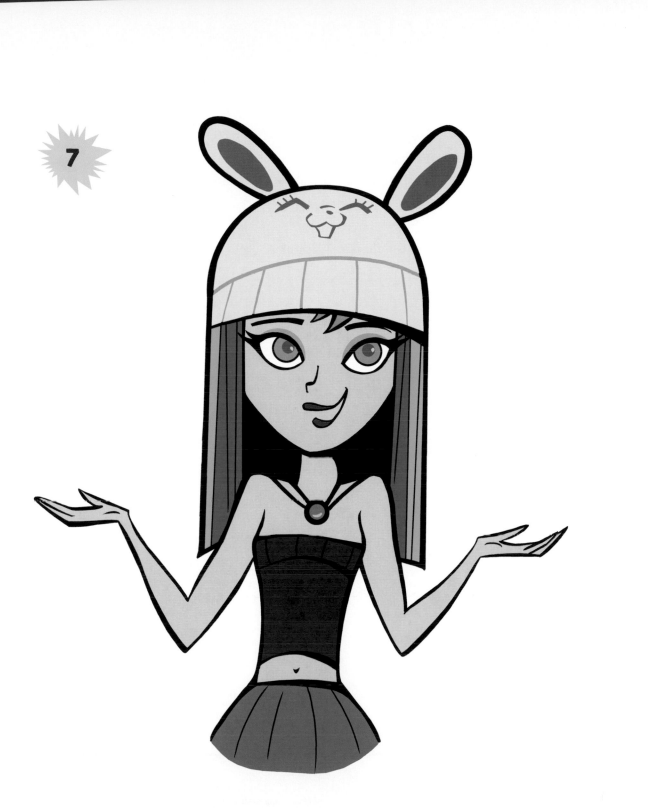

Shading is often thought of as only useful for creating a soft and
moody look. But here it's used to make the image livelier. This final
cartoon contains a range of shading, from light to dark.

SPORTY ATHLETE

Here's a current variation on a fun character type. In the recent past, characters with impressive builds were mostly depicted as jocks. Now, however, their build is used more as a change of pace from the rest of the characters. This bright-eyed, smartly dressed guy has an idea about something. Curious what it is? I wonder if I can guess what it is? He's thinking about . . . replacing his crankshaft?

I'm right? Yay!

If you can make the viewer wonder what the character is thinking, your drawing is successful.

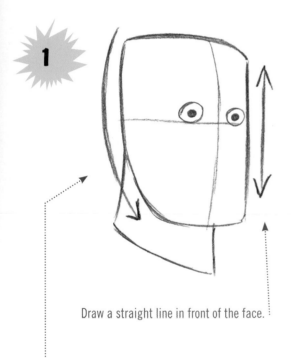

Draw a straight line in front of the face.

Make a curved line in back of the head.

Modern cartoons are all about bold lines. Draw straight lines very straight and curved lines very curved.

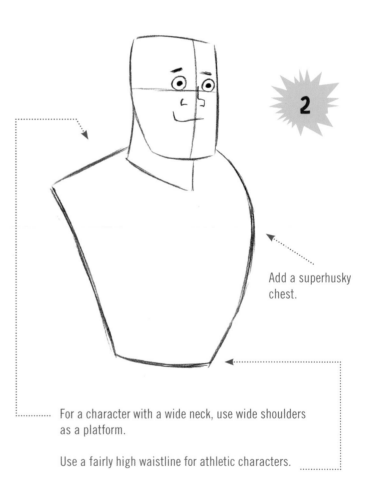

Add a superhusky chest.

For a character with a wide neck, use wide shoulders as a platform.

Use a fairly high waistline for athletic characters.

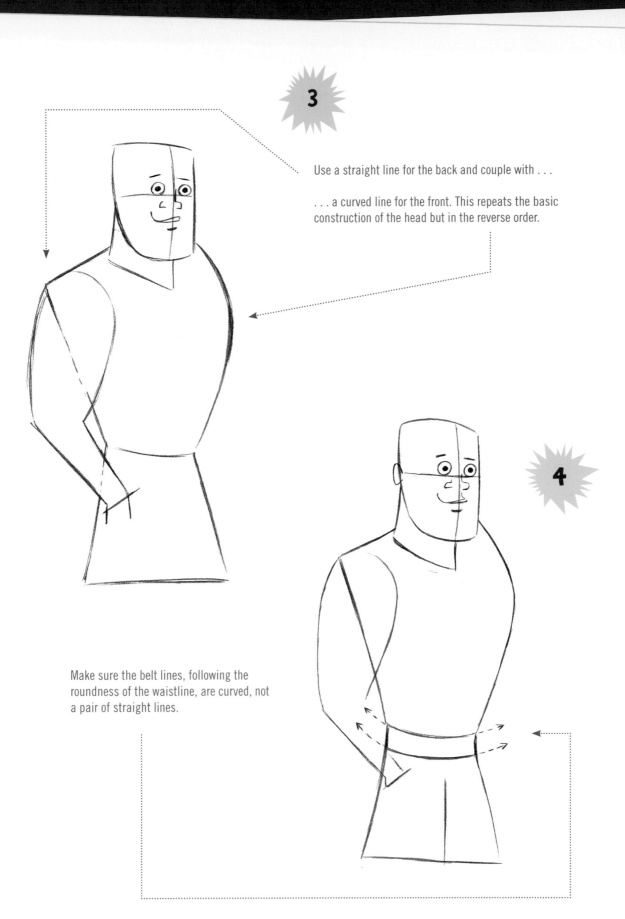

3

Use a straight line for the back and couple with . . .

. . . a curved line for the front. This repeats the basic construction of the head but in the reverse order.

4

Make sure the belt lines, following the roundness of the waistline, are curved, not a pair of straight lines.

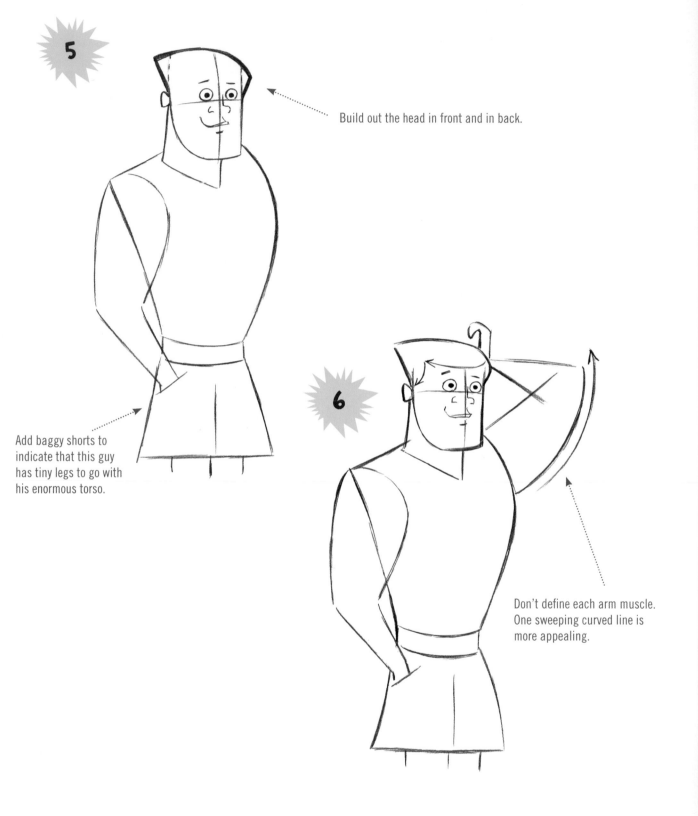

5

Build out the head in front and in back.

Add baggy shorts to indicate that this guy has tiny legs to go with his enormous torso.

6

Don't define each arm muscle. One sweeping curved line is more appealing.

7

Compare this final image to the first construction. Notice how all the individual parts come together smoothly. That's partly due to using long sweeping lines, rather than short choppy ones.

FIRST SNOWFLAKE

This character is meant to be sweet and filled with wonder as she enjoys the winter's first snowfall. In order to contribute to the serenity of the scene, the character design must be charming. Therefore, keep it a little subdued, not wacky.

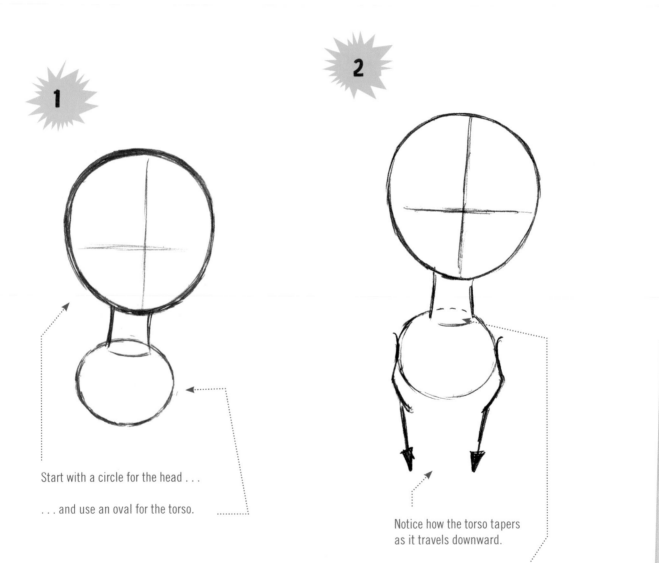

1

Start with a circle for the head . . .

. . . and use an oval for the torso.

2

Notice how the torso tapers as it travels downward.

Place the neck *inside the torso*, do not stick it on top.

3

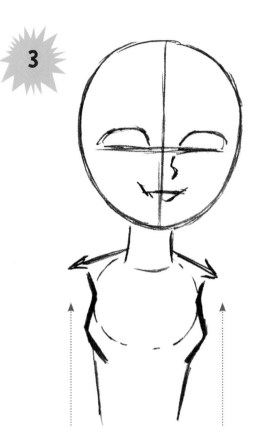

Slope the shoulders—but not too much, or she'll look wimpy!

4

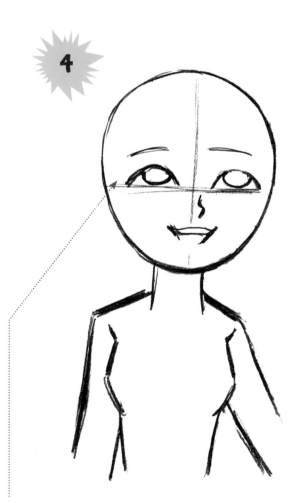

Change the eye from a circle to an oval where the head tilts back.

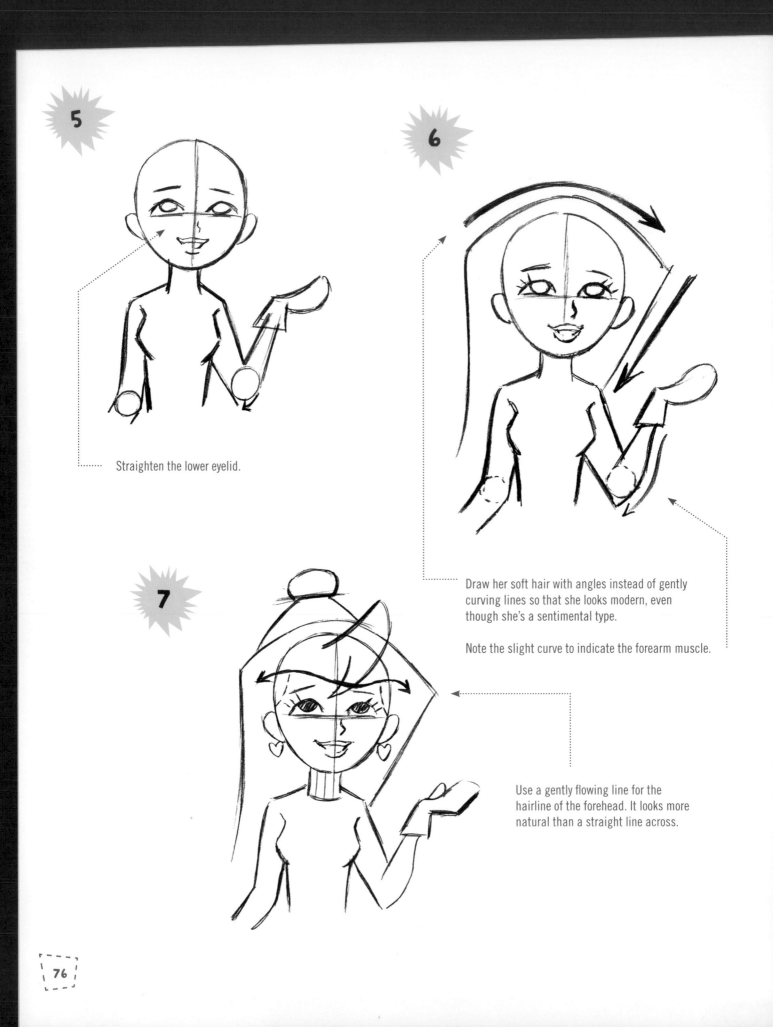

5

Straighten the lower eyelid.

6

Draw her soft hair with angles instead of gently curving lines so that she looks modern, even though she's a sentimental type.

Note the slight curve to indicate the forearm muscle.

7

Use a gently flowing line for the hairline of the forehead. It looks more natural than a straight line across.

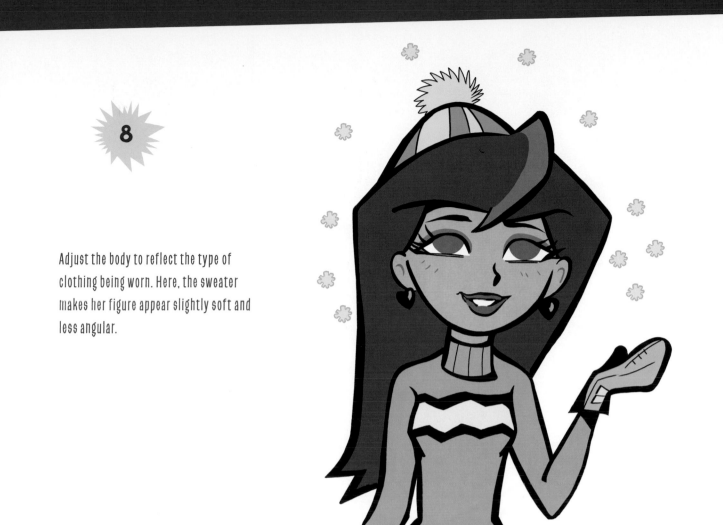

8

Adjust the body to reflect the type of clothing being worn. Here, the sweater makes her figure appear slightly soft and less angular.

EYE DETAIL—OVALS VS. CIRCLES

When the head tilts up and the eyes look upward, they change from circular to oval because of perspective.

THE UNIVERSAL BODY TYPE

Here's where the rubber meets the road, where boys become men, where one wrong move spells doom—and a bunch of other equally dramatic sayings. It's time to stick all of those heads you've been drawing on to cartoon bodies.

It's very easy to draw a body that, despite almost heroic efforts, comes out looking awkward. One reason is that when drawing a body, a cartoonist has to keep track of many elements at the same time: posture, arm and hand positions, and legs positioned for balance. But that's not the part that usually drives people crazy. It's creating an entirely new body type for each different character. This is typically what takes the most effort and thought.

But there's good news! I'm going to show you how to create a whole variety of body shapes using just *one basic starting point*. This way, you won't have to start from scratch each time. It's a method I've designed for my work, and now you can use it to develop your characters, too! So stop whatever you're doing right now, even if you're undergoing surgery. It can wait. Start drawing!

STANDARD CARTOON BODY TYPE

This bean-shaped body is the type that has been around for decades. And it works. It's cute. But that's the problem: It's just cute. It's not athletic, it's not skinny, it's not chubby, and it's not edgy. It offers only one look: cute. If you want to draw a different type of body, you've got to invent it from scratch.

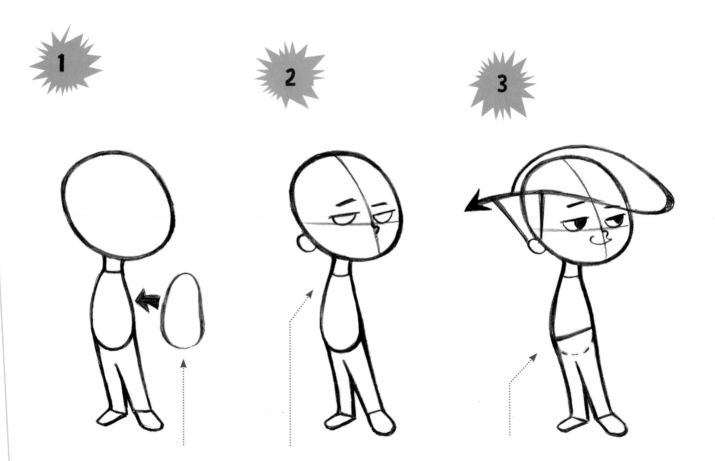

1

Draw this bean shape so that the front (tummy) part extends, while the back curves inward.

2

Notice that this body shape does not provide for shoulder width.

3

Use the belt line to cut off the underlying torso by about a third.

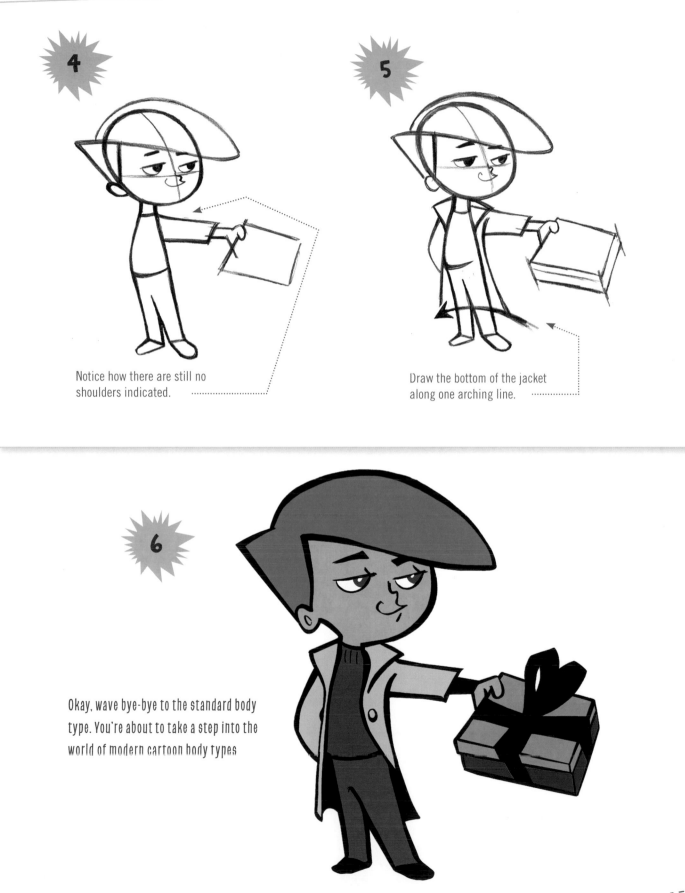

4

Notice how there are still no shoulders indicated.

5

Draw the bottom of the jacket along one arching line.

6

Okay, wave bye-bye to the standard body type. You're about to take a step into the world of modern cartoon body types

RUBBERY TORSO

The best way to create bodies—especially a variety of bodies—is by focusing primarily on the torso. This method gets you quicker results with half the effort. That allows you to get back to the real experience of cartooning, which is enjoyable and creative.

Look at the basic rectangle below. It's not particularly wide or tall. It's sort of average. But instead of thinking of it as having firm borders, think of the lines as rubbery. And they are! You can stretch and pull them mercilessly in many different directions to create new forms—and new torsos.

Start with a rectangle.

Modify the rectangle to an hourglass shape.

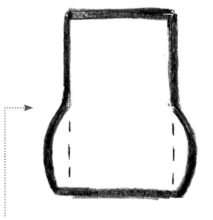

Out of shape: The "corn chips" belly shows an abrupt widening.

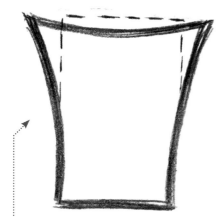

Athletic: This type is always top-heavy.

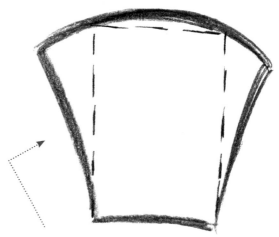

Bruiser: Rounded shoulders provide a hunched, powerful look.

Circumference-challenged: This torso has total thickness, all over.

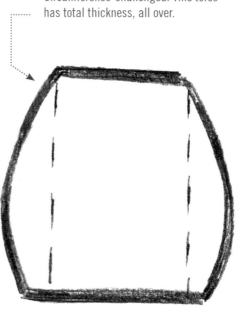

Use this variation to indicate a body facing three-quarters right.

SKINNY BODY --

This body type takes the rectangle and *s-t-r-e-t-c-h-e-s* it so that the torso becomes tall and thin. But it's stretched in such a way that it's no longer a true rectangle. Notice, too, how a single line flows seamlessly from the torso into the legs.

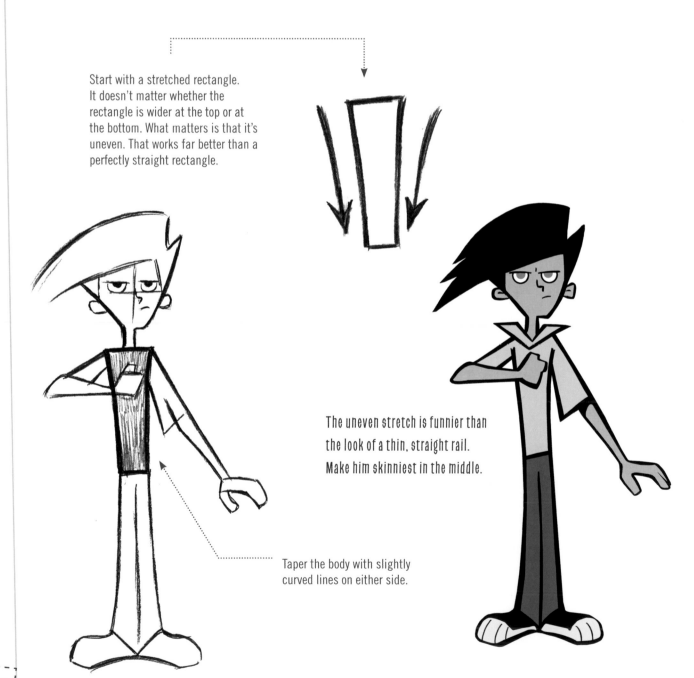

Start with a stretched rectangle. It doesn't matter whether the rectangle is wider at the top or at the bottom. What matters is that it's uneven. That works far better than a perfectly straight rectangle.

The uneven stretch is funnier than the look of a thin, straight rail. Make him skinniest in the middle.

Taper the body with slightly curved lines on either side.

V-TYPE BODY

The V-type body quickly widens at the shoulders, but the waistline is never really thin on muscular characters. The body shape is symmetrical: Both sides are the same size, length, and shape. For a humorous effect, keep the legs small and underpowered.

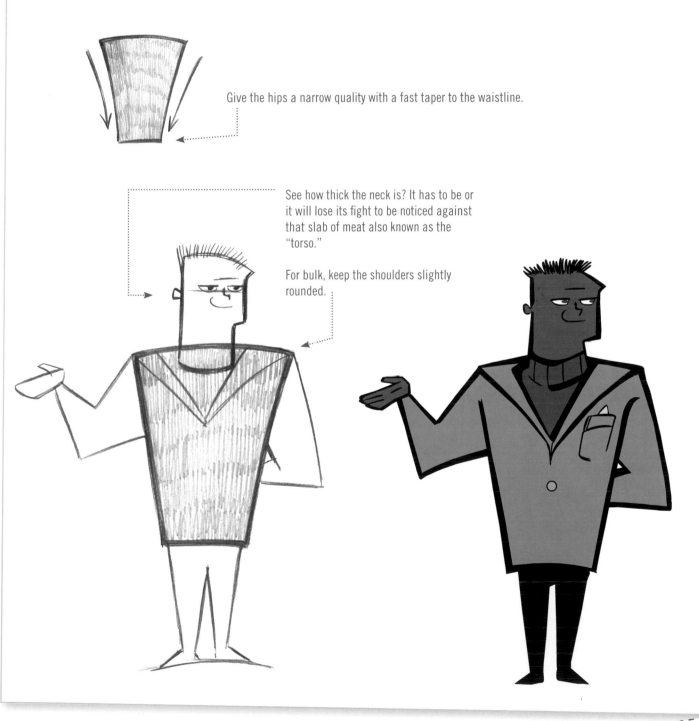

Give the hips a narrow quality with a fast taper to the waistline.

See how thick the neck is? It has to be or it will lose its fight to be noticed against that slab of meat also known as the "torso."

For bulk, keep the shoulders slightly rounded.

BIG BODY

Here the rectangle torso is stretched not upward but outward. To give the body a dynamic look, rather than a symmetrical and staid one, one side is straight and the other side is curved. For big characters, typically the arms and legs are highly caricatured, making them appear short by comparison to the size of the body. This unusual body shape features straight lines, curved lines, and diagonals. Quite a mixture.

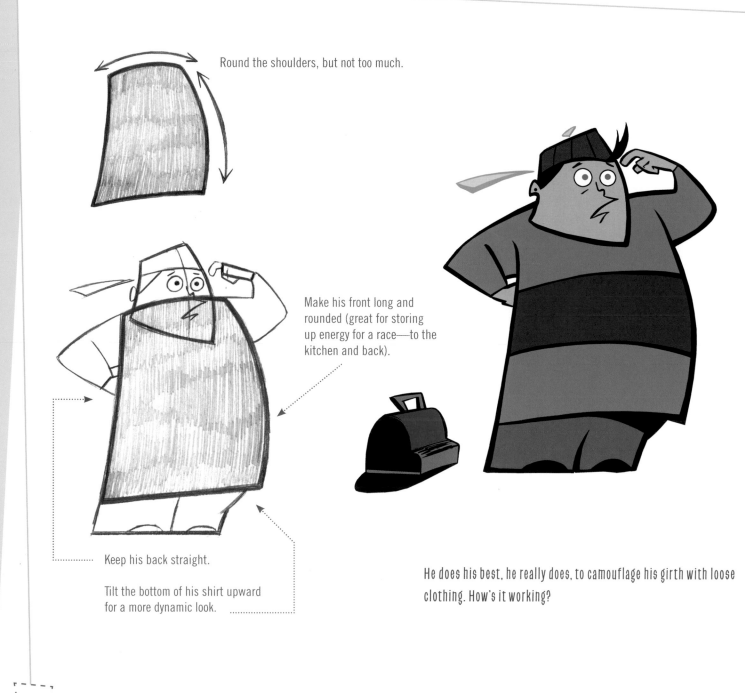

Round the shoulders, but not too much.

Make his front long and rounded (great for storing up energy for a race—to the kitchen and back).

Keep his back straight.

Tilt the bottom of his shirt upward for a more dynamic look.

He does his best, he really does, to camouflage his girth with loose clothing. How's it working?

A WORD ABOUT BIG BODIES

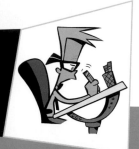

AN EVEN FUNNIER WAY TO DRAW BIG BODIES IS TO ALLOW THE GUT TO OVERHANG THE LEGS. DON'T MAKE IT A GRADUAL LINE BUT INSTEAD STOP ABRUPTLY AT THE WAIST, ALMOST AS IF THE TUMMY JUST DISAPPEARED. THIS IS A MUCH MORE HUMOROUS METHOD FOR DRAWING LARGE FIGURES.

Abbreviate the tummy by cutting it off at the shirt line.

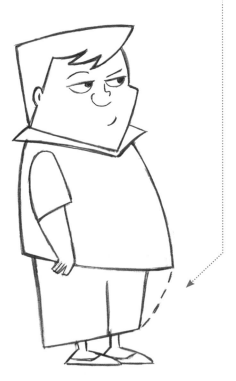

Now do the same thing in back. Two "overhangs"!

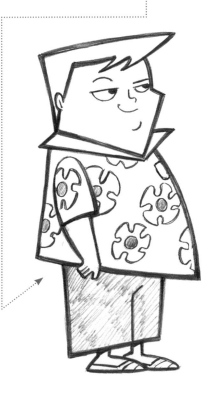

COMPACT TORSO

Compact torsos are super-versatile. They can be used to draw tiny kids, droopy teens, and middle-aged men. But shortening the rectangular torso isn't enough. It also has to be molded in order to add humor. Giving this tiny upper body a steep curve in front creates a tiny chest, which in itself is a funny look. And while the front is curved, the back is more of a straight line. Weak-looking characters such as this often have only virtual shoulders—in other words, what shoulders?

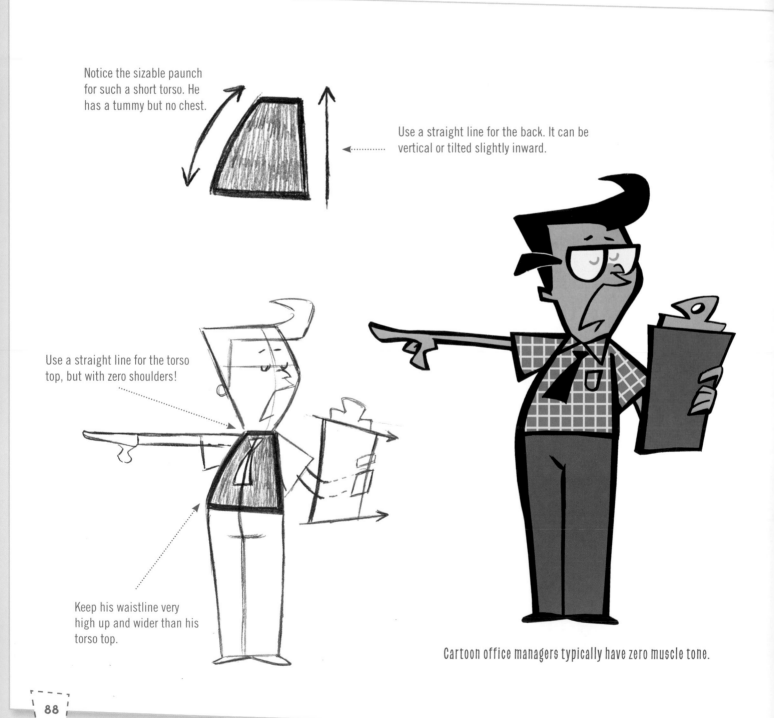

Notice the sizable paunch for such a short torso. He has a tummy but no chest.

Use a straight line for the back. It can be vertical or tilted slightly inward.

Use a straight line for the torso top, but with zero shoulders!

Keep his waistline very high up and wider than his torso top.

Cartoon office managers typically have zero muscle tone.

BUILDING THE TOTAL FIGURE FROM A SINGLE SHAPE

Okay, ready to live on the wild side? Once again you're going to create a single shape as the foundation for the character. But this time it's going to encompass the entire figure, *including the head*! Blown away? I'll give you a moment to regroup. The cool thing about designing a single, overall shape for a character is that, no matter what body type the character has, the look ends up being retro. As with most cartoon constructions, once you have the basic outline, you can begin to make adjustments. Some of these may cause minor adjustments to the single-shape purity of the outline, such as this character's overhanging tummy. But as long as you keep these exceptions few, it will still have that cool, sleek look.

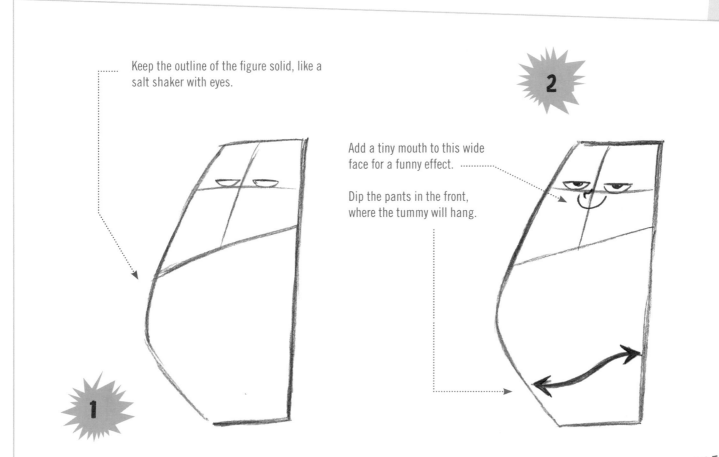

Keep the outline of the figure solid, like a salt shaker with eyes.

1

Add a tiny mouth to this wide face for a funny effect.

Dip the pants in the front, where the tummy will hang.

2

3

Use the center line to place
the center of the shirt.

4

To help emphasize the singleness of
the outline, either leave off his shoes
entirely or barely indicate them.

5

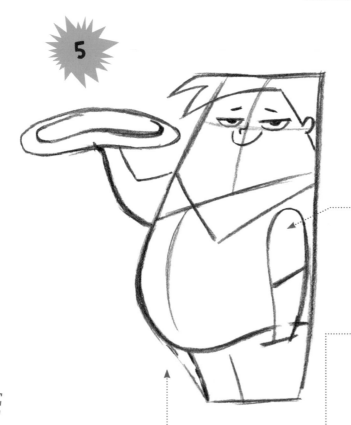

Bury his shoulders so deeply within the outline that
they're not of much use.

Carve out some of the leg mass to allow the tummy
to hang freely over the pants—plumber-style.

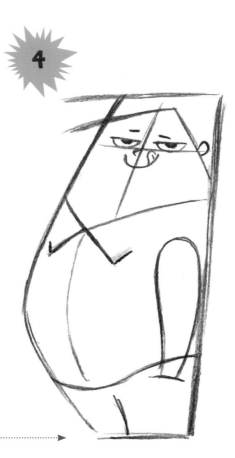

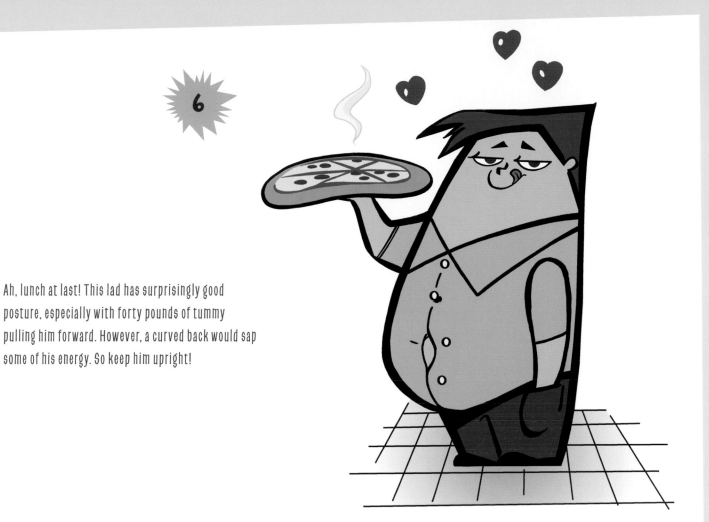

Ah, lunch at last! This lad has surprisingly good posture, especially with forty pounds of tummy pulling him forward. However, a curved back would sap some of his energy. So keep him upright!

HEAD VARIATIONS

ROUND HEAD

Just by adding a protruding cheek, you change the look.

BLOCK HEAD

Blockheads have no curves.

USING CLOTHING TO DEFINE BODY SHAPES

Let's pause briefly for one last hint about drawing the body. This hint will make your life easier: In some circumstances, you don't have to draw the body first and then draw the clothing on it. It never hurts to do so, and it's a good practice, in theory. But in some instances where characters are highly stylized, it may also be completely unnecessary.

What are those circumstances? It occurs when a character's body construction is totally masked by a stronger shape, such as clothing. For example, a character wearing a poncho doesn't need a body construction underneath it. What you want to concentrate on, instead, is drawing a clear and uncomplicated outline of the outfit so that it is a new, virtual body shape.

OVERCOAT

Notice how the outline of the coat comfortably substitutes for a basic body construction. But it has a little help—it's narrower in the middle than a regular overcoat would be. This technique helps mimic the shape of the body underneath.

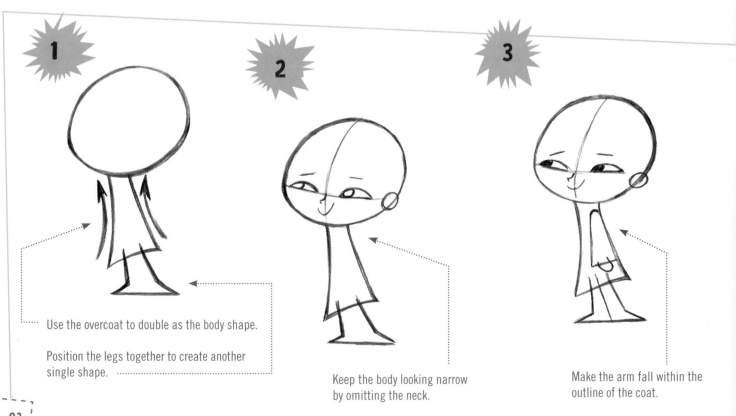

Use the overcoat to double as the body shape.

Position the legs together to create another single shape.

Keep the body looking narrow by omitting the neck.

Make the arm fall within the outline of the coat.

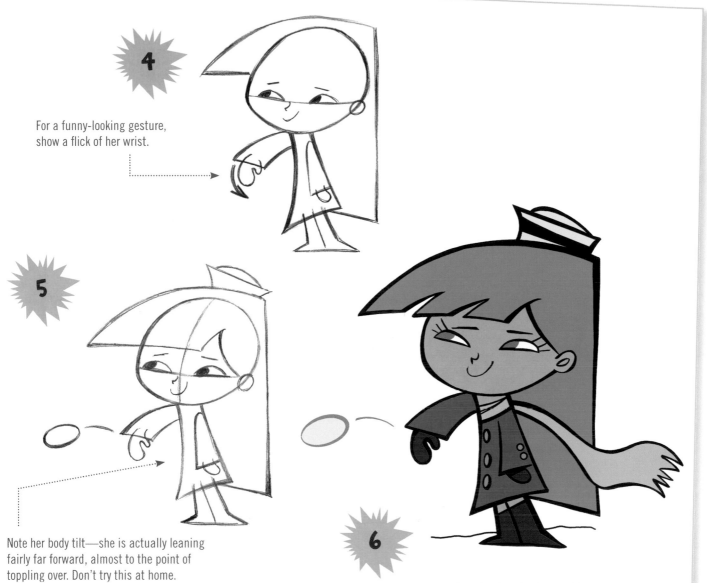

4

For a funny-looking gesture, show a flick of her wrist.

5

Note her body tilt—she is actually leaning fairly far forward, almost to the point of toppling over. Don't try this at home.

6

Note the ridiculous little speed line.

VARIATION

This type of energetic action is flashier but offers less personality than the stiffer version.

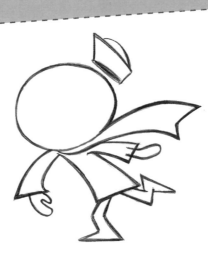

SHIRTS AND PAJAMA TOPS-------------------------

Leaving pajama tops or shirttails untucked creates a quasi-torso shape that can be used as the basis of the body. But this needs to be camouflaged. If the top looks just like a torso, it spoils the entire concept. Therefore, you have to find a way to make the pajama top look like a pajama top and not like the torso. Since a pajama top should look larger than the torso, draw the legs narrowest at the top, where they meet the bottom of the shirt. This will make the bottom of the shirt appear even wider.

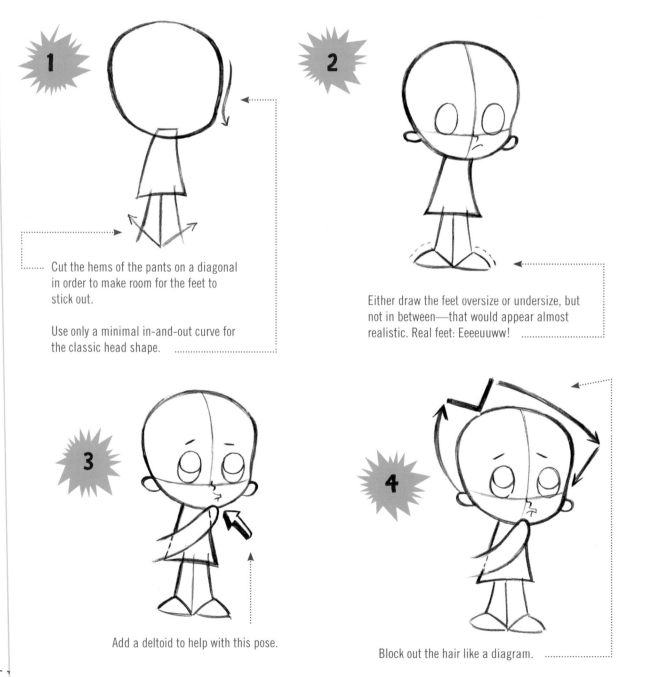

1

Cut the hems of the pants on a diagonal in order to make room for the feet to stick out.

Use only a minimal in-and-out curve for the classic head shape.

2

Either draw the feet oversize or undersize, but not in between—that would appear almost realistic. Real feet: Eeeeuuww!

3

Add a deltoid to help with this pose.

4

Block out the hair like a diagram.

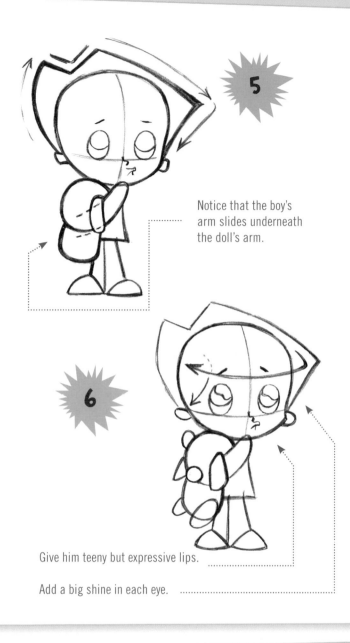

5

Notice that the boy's arm slides underneath the doll's arm.

6

Give him teeny but expressive lips.

Add a big shine in each eye.

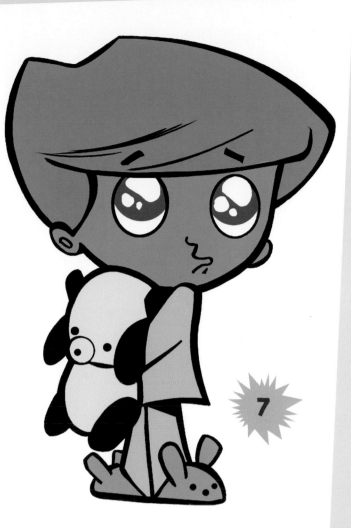

7

So cute, you just want to pinch him 'til he pops!

FACIAL OUTLINE VARIATIONS

Both of these facial outline variations are cute. The protruding cheek is slightly cuter, but the straight line is more "retro."

WOMAN IN CAPE

This very large piece of clothing also serves as a foundational body shape. Because it's so wide, it makes drawing a construction figure underneath it all but impossible. The bell shape serves as your starting point. The cape is big. Little legs make it look like a bell.

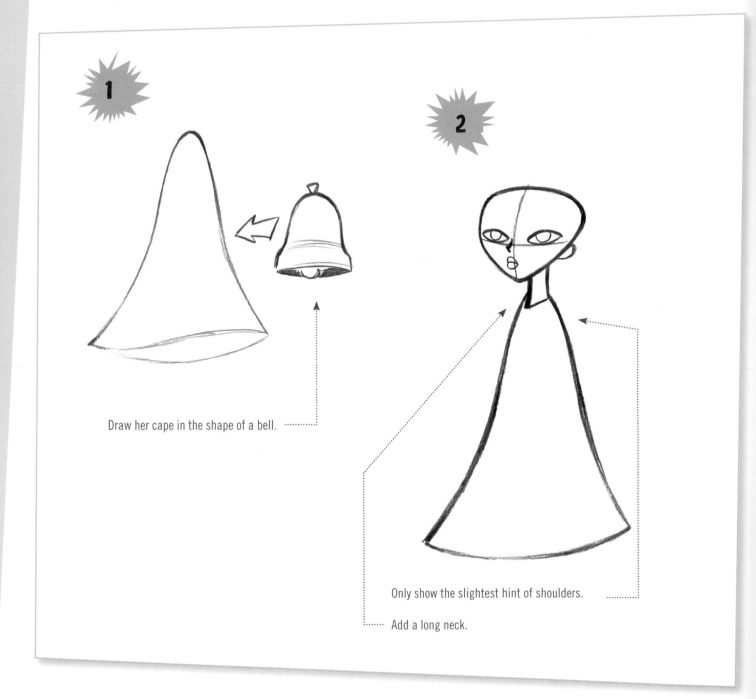

Draw her cape in the shape of a bell.

Only show the slightest hint of shoulders.

Add a long neck.

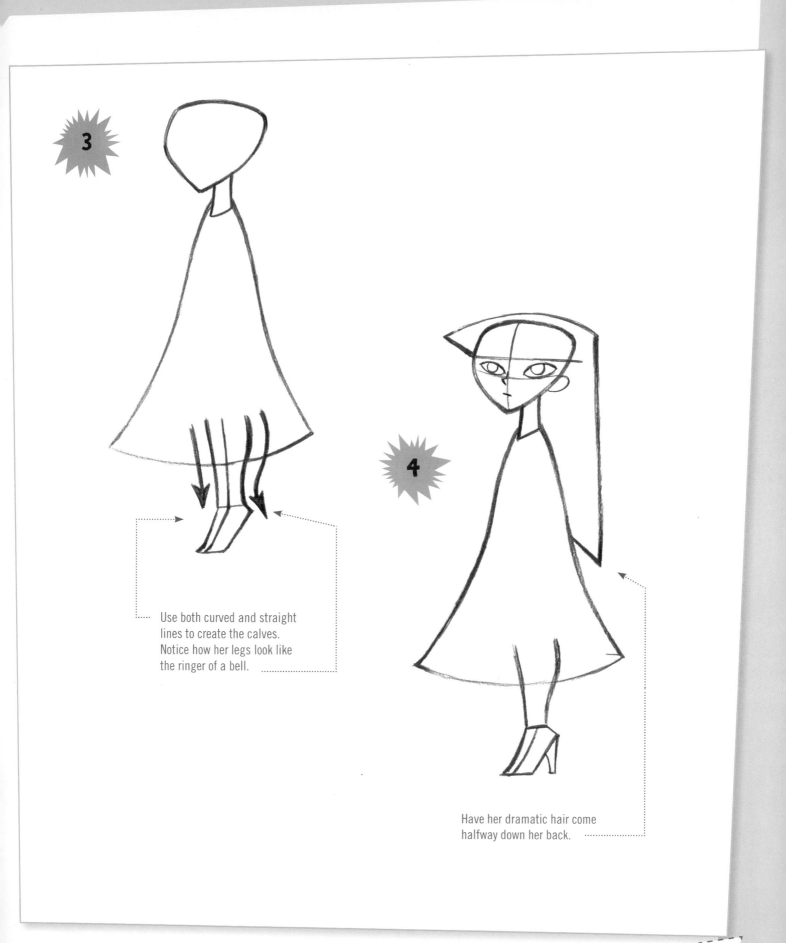

3

Use both curved and straight lines to create the calves. Notice how her legs look like the ringer of a bell.

4

Have her dramatic hair come halfway down her back.

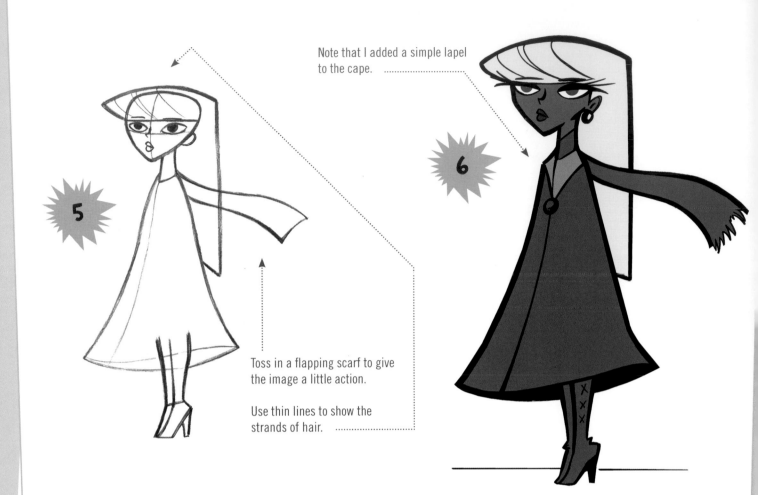

Note that I added a simple lapel to the cape.

5

6

Toss in a flapping scarf to give the image a little action.

Use thin lines to show the strands of hair.

BOOT DETAILS

GOOD
Boots form-fit the feet.

BETTER
It's funnier to draw the boots in a quirky manner. The disadvantage is that they only come in a size 7.

UNNECESSARY BODY CONSTRUCTION

SEE HOW REDUNDANT THIS STEP IS? THERE IS NO NEED TO DRAW THE UNDERLYING BODY SHAPE BEFORE STARTING ON THE CAPE. IT WOULD WASTE YOUR TIME. I, ON THE OTHER HAND, AM FORCED TO WASTE MY TIME ON IT. PARTLY BECAUSE I AM TEACHING THE CONCEPT AND PARTLY AS PENANCE FOR SOMETHING I MUST HAVE DONE IN A PAST LIFE.

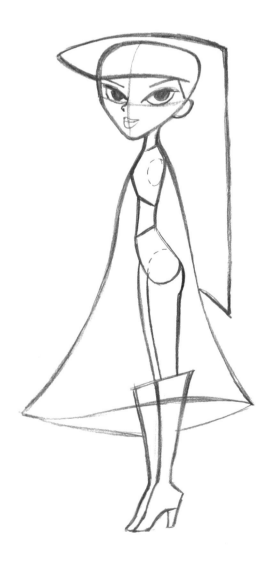

DRAWING THE FEMALE BODY: TEENS THROUGH ADULTS

The key to drawing the female cartoon body is, in a word, compartments. See how the different parts of the body are "assembled" into a single figure?

The standard female torso is broken into three major sections: the chest, represented by an oval; the hips, drawn like a bowl; and the trunk, which is the long, flexible section that connects the two.

After reading that, you're probably thinking: "That can't be all there is to drawing the female body. My goodness, it doesn't look complicated at all!" My response is: "Yes, my friend, oh yes."

Like many of the initial constructions in this book, this one also needs a few minor adjustments before it's ready to be called a final drawing. These minor changes will transform the look of the body from a mannequin to a personality-driven character, minus the look of segmentation with which it began.

BASIC CONSTRUCTION ----------------------------------

Here's the figure, deconstructed. Note that everything about her basic construction is narrow—except the hip area, which remains wide.

Another reason why the body is drawn thin is to make the head appear slightly oversized by contrast. And even though the figure is lanky, it is rarely tall—unless you're drawing fashion models.

You can modify all of these shapes to create individual characters.

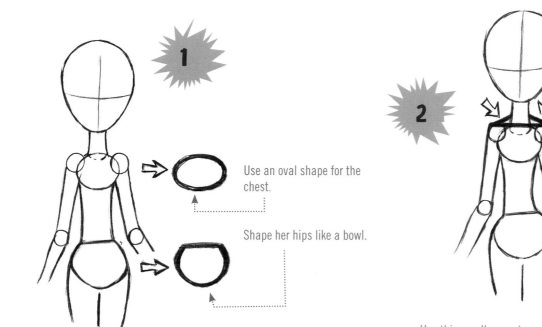

1

Use an oval shape for the chest.

Shape her hips like a bowl.

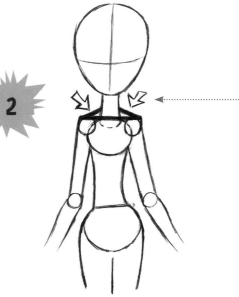

2

Use this small mass to connect the neck to the shoulders, making the transition less abrupt.

3

Refine the shape of her chest.

Notice the direction of the vertical lines of the chest.

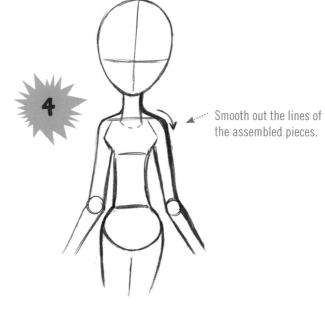

4

Smooth out the lines of the assembled pieces.

BUILDING BLOCKS --------------------------------

Now let's see how the building blocks covered previously look on a finished figure. This isn't a step-by-step section, though you can certainly draw these characters using the body-type breakdowns. I designed these characters to demonstrate the concept so that when you draw the figures, you'll do more than merely copy them—and you'll also comprehend the principles you're applying. The techniques will get lodged in your head, like a song by Abba, which you just can't get rid of.

FRONT VIEW

In the front view, the shoulders give the body its width.

Basic Construction: Foundation Shape
Foundation shapes should always be simple and clear.

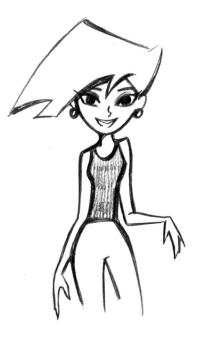

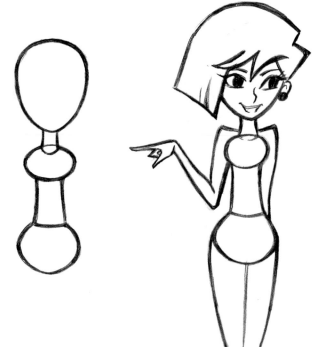

Application of the Concept: Notice that in this medium shot, I've included a good deal of the legs, which can make the medium shot look like the wrong shot selection. And yet the character appears to be well framed. That's because I ended the image *above* the knees rather than cutting her off *at* the knees.

See how the shape works as the center of the complete body.

SIDE VIEW

Note how each section—chest, trunk, and hips—is drawn at a slightly different angle. And yet, the aim should be to smooth out those different angles so that they appear to flow. She is thinner in the side view than in the front. But don't make the mistake of drawing her unnaturally thin. Maintain the mass in the chest and hips.

Basic Construction: This is the thinnest of any angle. Next time you feel fat, just walk around facing your friends sideways, and they'll be impressed by how much weight you've lost.

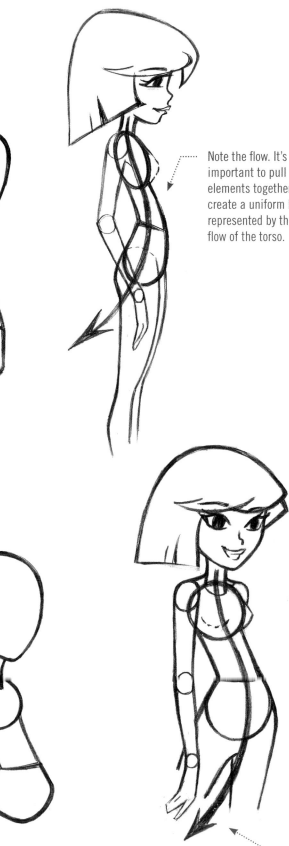

Note the flow. It's important to pull all the elements together to create a uniform look, represented by the overall flow of the torso.

3/4 VIEW

Turned to face us at a forty-five-degree angle, some elements of the female body now require a bit of adjustment in order to align with the slight amount of perspective that comes into effect in every 3/4 pose. The far arm is hidden from view.

The near breast is drawn in a front view, while the far one is drawn in a side view. And the near leg slightly overlaps the far one.

Note that she's leaning back. This gives her a slinkier look and helps her avoid the bad breath of the guy hitting on her.

Basic Construction: This view features a slightly thicker torso because of perspective, which occurs when the body shifts out of front view.

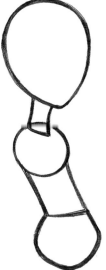

Notice that the flow is created with a gently winding curved line.

Take the basic construction and compare it to the final image. What do you notice? That I go through a lot of pencils? Yes, good point, but there's even more. Notice that it's the torso—that single shape comprised of the chest, trunk, and hips fused together—that is the most important element when beginning to draw a pose. The arms and legs come in once the foundation of the torso is in place.

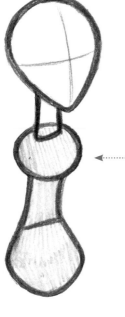

Foundation of the torso and the head are drawn first.

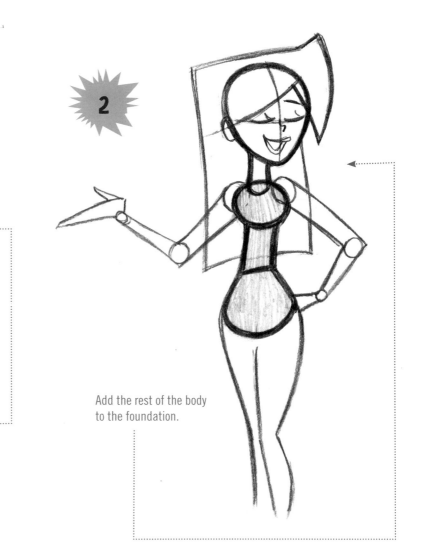

Add the rest of the body to the foundation.

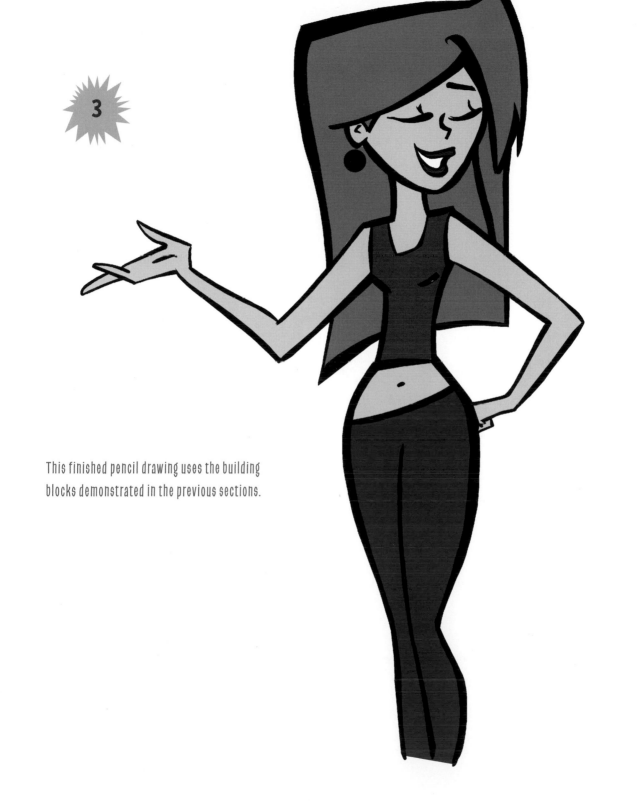

3

This finished pencil drawing uses the building blocks demonstrated in the previous sections.

PUTTING YOUR CHARACTERS TOGETHER

Now that you've grasped the concept of constructing the body, wrestled it to the ground, pinned it, and made it cry out for mercy, you can move on to the next step: finished characters.

Here's an important hint: If you work on each construction element in the step-by-step examples until you can't improve it any more, then everything will fall into place much more easily when you get to the final drawing. But a word of caution: Do not linger on each step so long that you begin to enter what I refer to as the "De-provement Zone." I've ruined many a good drawing by improving it until it stops working. So work hard, but don't obsess. Stay out of the zone!

CAN NEVER HAVE ENOUGH SHOES

This pro-level shopper is having a great day in Palm Beach. Therefore, the store owners are having a fine day, too. She glances over at us, the viewer, with a knowing smile. This fun gesture works better than if I just turned her to face in the viewer's direction. To do that would take away from her attractive and sly look. Her look should reflect that she's *aware* that the viewer is looking at her.

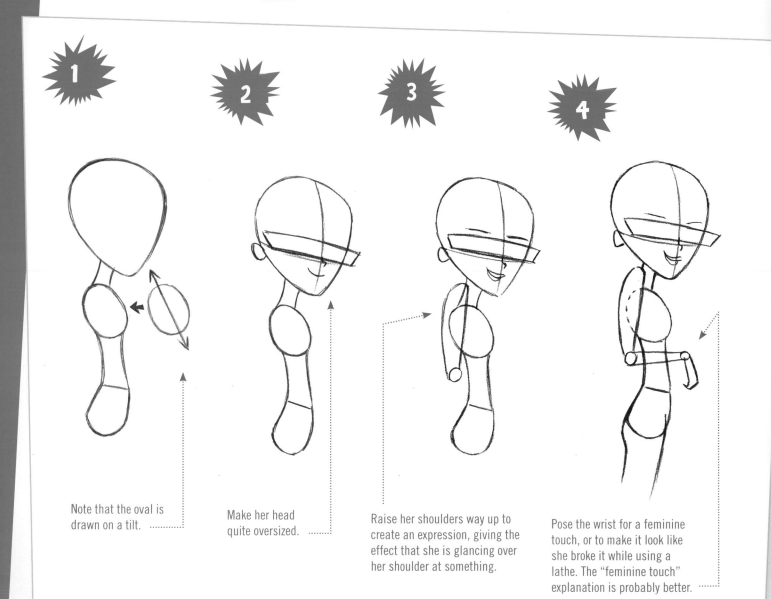

1 Note that the oval is drawn on a tilt.

2 Make her head quite oversized.

3 Raise her shoulders way up to create an expression, giving the effect that she is glancing over her shoulder at something.

4 Pose the wrist for a feminine touch, or to make it look like she broke it while using a lathe. The "feminine touch" explanation is probably better.

5

Sweep her hair back smartly.

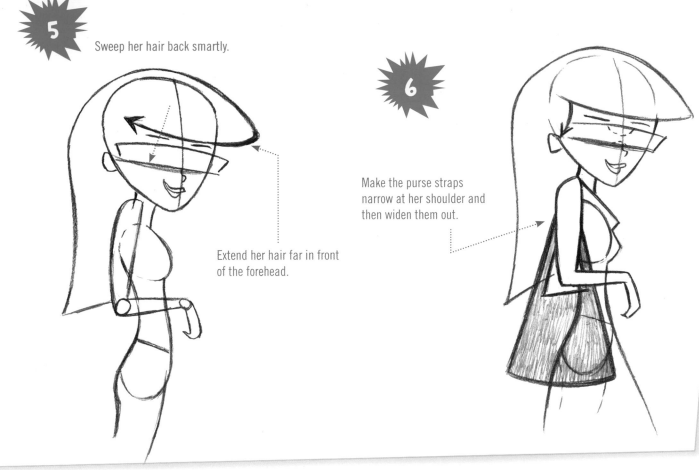

Extend her hair far in front of the forehead.

6

Make the purse straps narrow at her shoulder and then widen them out.

7

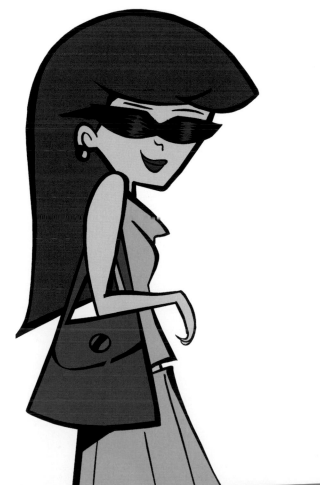

Note that there's a little highlight on each lens of the sunglasses so that they don't look opaque.

FUNNY STANCE

Here's a friendly, somewhat goofy gal. She's a versatile character. You can tweak her so that she becomes an older sister, or a college roommate, or a young mom, or even a super action hero. Well, maybe not quite *that* versatile.

Watch how her cartoony posture works like dominoes: Her head hangs forward, which causes her shoulders to slouch in poor posture, which causes her to stand with her feet pointed sideways, like a penguin, in order to maintain balance.

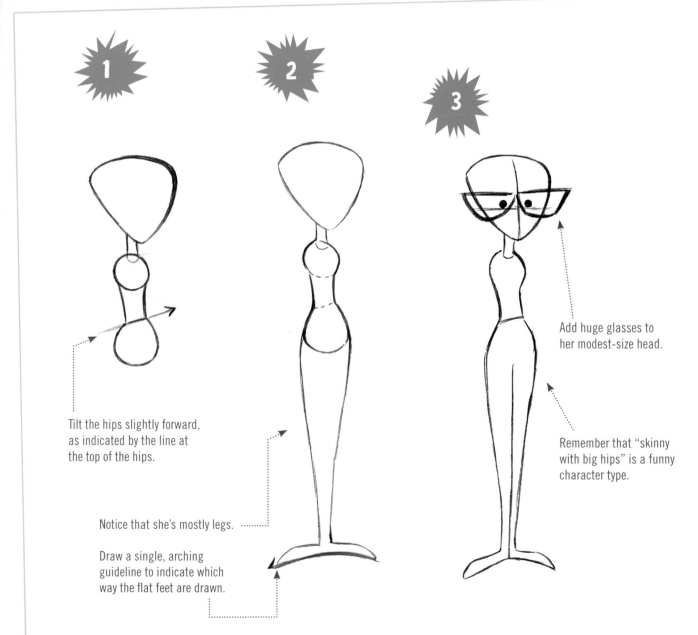

Tilt the hips slightly forward, as indicated by the line at the top of the hips.

Notice that she's mostly legs.

Draw a single, arching guideline to indicate which way the flat feet are drawn.

Add huge glasses to her modest-size head.

Remember that "skinny with big hips" is a funny character type.

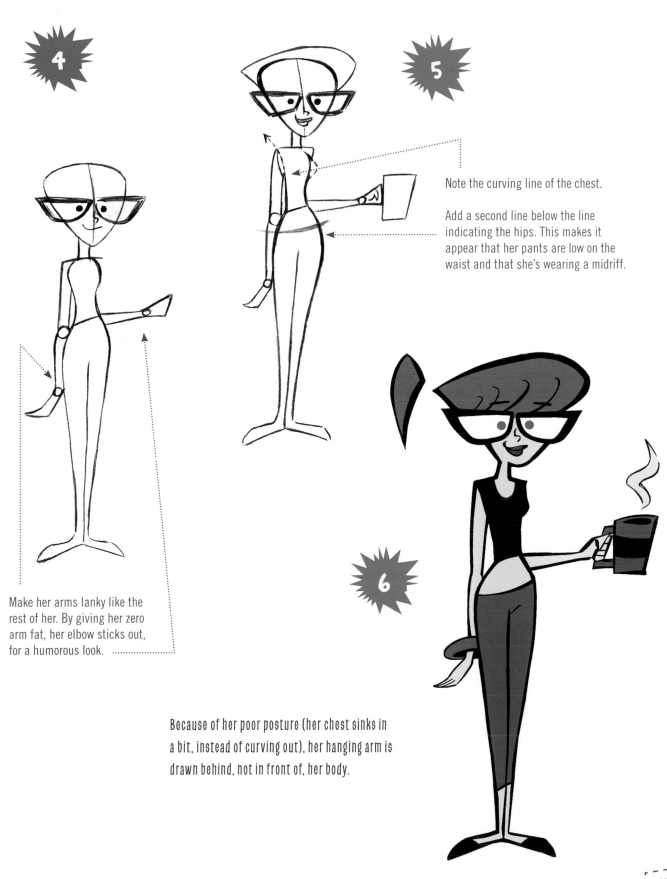

4

Make her arms lanky like the rest of her. By giving her zero arm fat, her elbow sticks out, for a humorous look.

5

Note the curving line of the chest.

Add a second line below the line indicating the hips. This makes it appear that her pants are low on the waist and that she's wearing a midriff.

6

Because of her poor posture (her chest sinks in a bit, instead of curving out), her hanging arm is drawn behind, not in front of, her body.

MERRY CHRISTMAS TO ME!

Here's an interesting character for you. She demonstrates several aspects of overlapping. The most obvious is the gift box she is carrying. Or, specifically, the arm that's holding it. What about it? Many newer artists feel that it's important to show both arms so that the viewer doesn't see the image as flat. But just drawing the far hand, which is gripping the box is sufficient to give the illusion of depth.

You could also position the legs apart, to make it quite obvious that there are two of them. But they would then lose their sleek look. Oh, what to do? Just suggest depth with a small accent rather than by showing it overtly. Draw the far limb so it protrudes just a touch.

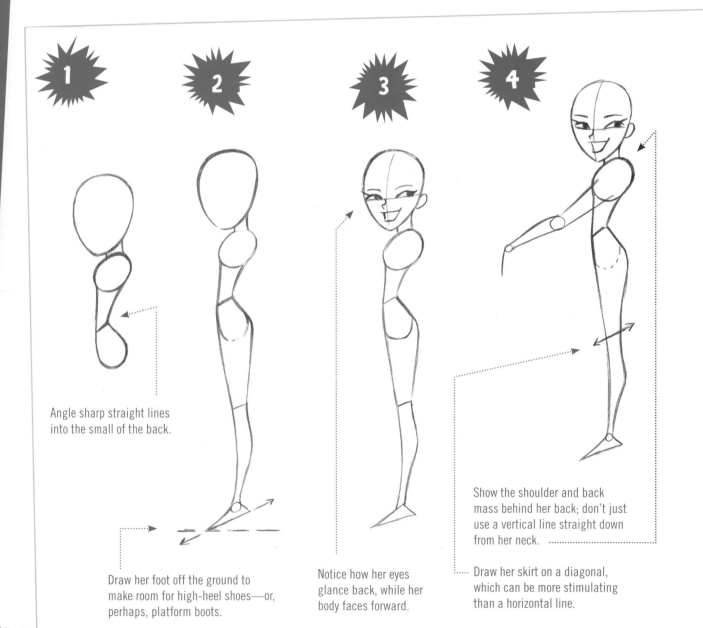

Angle sharp straight lines into the small of the back.

Draw her foot off the ground to make room for high-heel shoes—or, perhaps, platform boots.

Notice how her eyes glance back, while her body faces forward.

Show the shoulder and back mass behind her back; don't just use a vertical line straight down from her neck.

Draw her skirt on a diagonal, which can be more stimulating than a horizontal line.

5

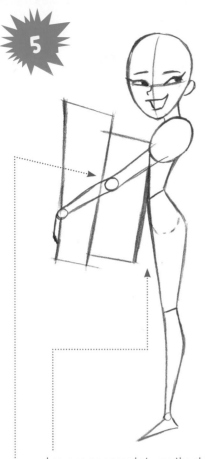

Leave some space between the object being held (box) and the body.

Even though the arms are outstretched, leave a tiny bend in them. This makes her look more lifelike.

6

Add a shadow where one object overhangs another.

Hint at a second foot for a feeling of depth.

7

What makes this character's body shape interesting? It's the fluid nature of the line. As it works its way around the outline of the figure, it flows smoothly. It doesn't pause or change angle as it goes from body section to body section. It just winds around them, like a wet noodle.

EHANCING AN EXISTING DRAWING

Redrawing, as well as doing additional drafts of the same character, is part of the process of cartooning. Redrawing is about more than repairing mistakes. It's how you learn to embellish a character—to *enhance* its appearance and impact on the viewer.

Let's start with the drawing from page 113. Let's say that, although you're happy with this drawing, you're not yet certain it's a "keeper." What do you do? Try tweaking it to see whether it improves or if the original version is best. You might want to take the initial drawing and enhance it by ratcheting up the character's energy level and giving her a more specific action. For example, instead of simply holding a box full of what are presumably clothes, handbags, or boots, tweak the character so that she's attempting to conceal them from her husband. But he finds out anyway. And they get into an argument. But she wins. How come I can never be the one who wins?

ENHANCING BODY -

Use moderation when tweaking a character, and when eating potato chips. I'm certain about this approach in both cases. If you overdraw the character, you won't have different versions of the same drawing to choose from but different drawings, period. With this approach, you're looking for new versions, not new characters.

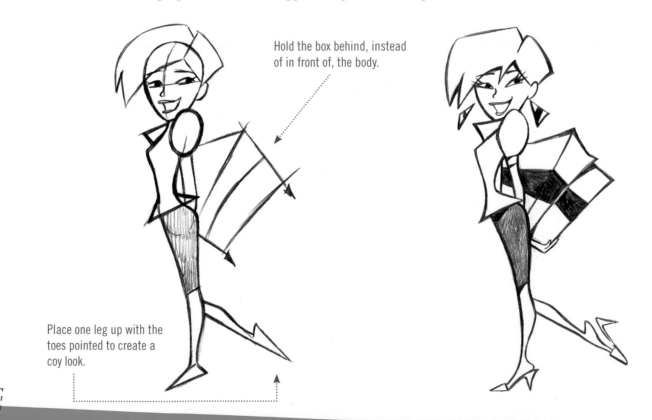

Hold the box behind, instead of in front of, the body.

Place one leg up with the toes pointed to create a coy look.

114

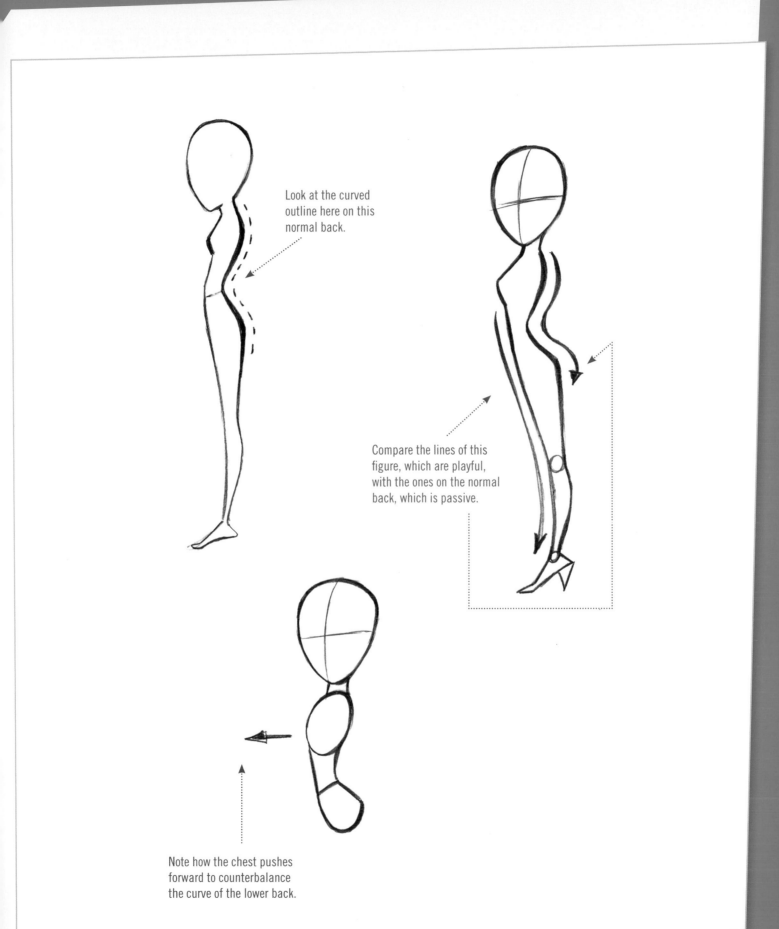

Look at the curved outline here on this normal back.

Compare the lines of this figure, which are playful, with the ones on the normal back, which is passive.

Note how the chest pushes forward to counterbalance the curve of the lower back.

ENHANCING THE FACE

Here are a few notes to help you give the character the final touches that make her sparkle.

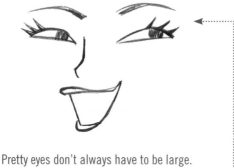

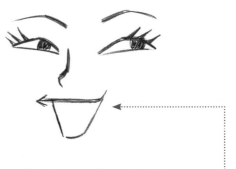

Pretty eyes don't always have to be large. Sometimes you can make them squint to highlight the character's weapons-grade eyelashes.

Make her upper lip go straight across. Create her smile with the curve of the bottom lip.

ENHANCING THE FEET

Female feet are all about graceful lines. That, and Prada.

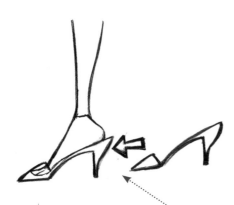

Don't forget that the foot and the shoe are two different shapes.

Use a long, sweeping arch for the shape of the foot in high heels.

Study the basic foundation and angle of the female foot.

INITIAL SKETCHES

NOW THAT I'VE SHOWN YOU HOW YOU CAN TAKE A FINISHED DRAWING AND BUMP IT UP ANOTHER NOTCH, LET'S TAKE A QUICK LOOK AT SOMETHING NOT TOO MANY HAVE THE OPPORTUNITY TO SEE: SOME FIRST-DRAFT SKETCHES THAT ARE EARLY VERSIONS OF A CHARACTER. WHY AM I SHOWING THIS TO YOU? BECAUSE I AM RUNNING LOW ON MY PAGE COUNT? OH, YOU ARE A SKEPTICAL ONE, BUT NO. THE REASON I OFFER THESE EXAMPLES IS TO SHOW YOU JUST HOW MESSY REDRAWING CAN BE. THE PROCESS OF SEARCHING FOR THE RIGHT FORM IS NOT THE TIME TO TRY TO DRAW PERFECTLY OR TO SELF-EDIT. THAT COMES AT THE CLEANUP STAGE. BEGINNERS USUALLY CONFLATE THE TWO, AND AS A RESULT, IT OFTEN DOESN'T WORK OUT THAT WELL. IN FACT, IT CAN LEAD TO DISASTER. OR, AT LEAST, THE DRAWING MIGHT NOT BE AS GOOD AS IT OTHERWISE COULD. WHICH IS, AS I SAID, A DISASTER.

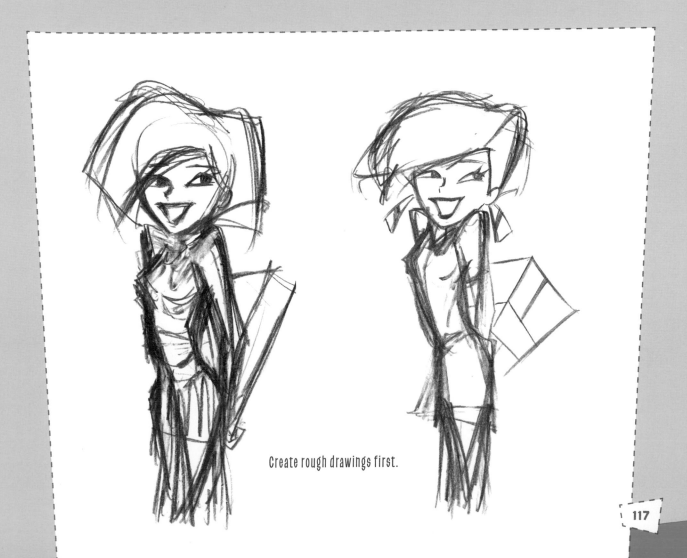

Create rough drawings first.

DIFFERENT BODY TYPES

Not every type of body can neatly fit into a category according to age, gender, and so on. Some body types are squat, some are athletic, and some are downright silly.

What do you do with characters whose body types are odd or unique? Avoid drawing them? Yes. The end. Next chapter.

I was just kidding. Sort of. But the problem is a real one. Therefore, the question is: How do cartoonists create a starting point for characters with unconventional shapes? Simply invent a new shape. Even though the shape is a new creation, you should still try to make it as uncomplicated and basic as possible.

Don't shy away from portraying traits like poor posture, potbellies, or chubby fingers. Instead, capitalize on these quirky traits—emphasize them—and you'll come away with a funny, fresh character design.

DORKY DAD

There is only one kind of dad in cartoons: the one you don't have—always good-natured, with no temper (or brains). These dad types have a wide variety of body shapes—all of them funny. This guy's torso is built like a horizontal melon wedge. A jaunty chin is a requirement on all cartoon dads. Glasses, too. And they wear a tie everywhere. The goal of the cartoonist is to make this character appear well groomed and neatly dressed but goofy at the same time. Note his skinny arms and legs. It's the perfect build for pushing paper and paper clips around all day.

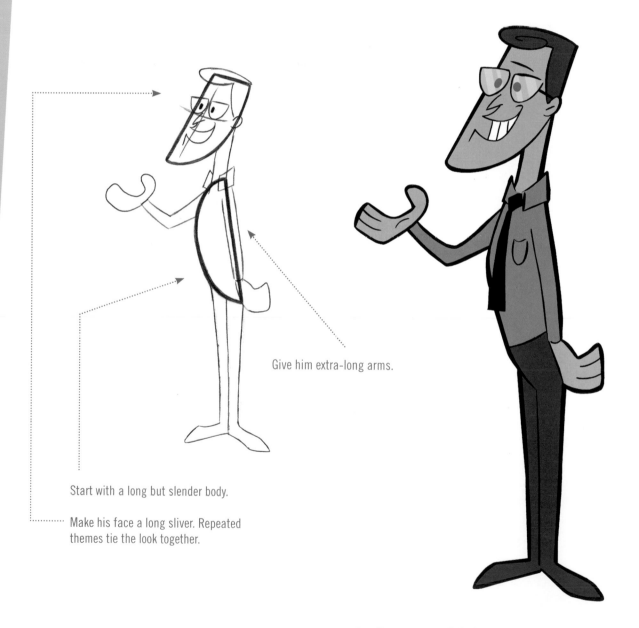

Give him extra-long arms.

Start with a long but slender body.

Make his face a long sliver. Repeated themes tie the look together.

Totally conventional clothes make him so "uncool" that it's cool!

Squared-off fingers or rounded
ones: either type is funny.

Another version of the goofy
dad body is created with an
inward-curving torso.

Knees? What knees?

1950s Mom

Zapped from the 1950s and hurled into the present by some cosmic force available only to cartoonists, the mom character is friendly and always helpful. Incredibly helpful. So helpful, you want to scream. But in a good way. You can draw mom with many different body types, but perhaps the funniest is the plump type, which features oversized calves and arms. The key to drawing this type is to make her round and yet stiff-looking at the same time.

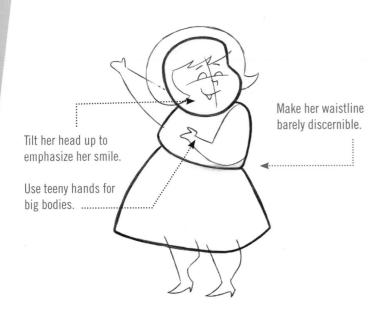

Tilt her head up to emphasize her smile.

Use teeny hands for big bodies.

Make her waistline barely discernible.

Note the mandatory tile floor for mom.

MOM DETAILS

THE BODY IS DIVIDED INTO ONLY TWO COMPARTMENTS INSTEAD OF THREE. BUT THE LARGE HEAD BECOMES THE THIRD MAJOR COMPONENT IN THE CONSTRUCTION.

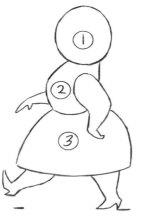
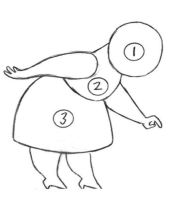

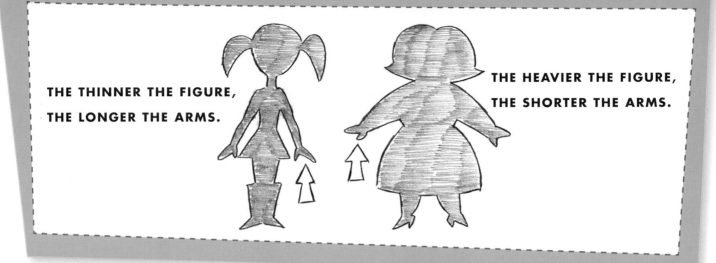

THE THINNER THE FIGURE, THE LONGER THE ARMS.

THE HEAVIER THE FIGURE, THE SHORTER THE ARMS.

TRAILER MOM

Here's the low-rent version of mom. She stands with her shoulders up high and her torso wedged into a solid mass, also known as "hips." The pointy glasses make this character look slightly nuts. Both ears are drawn sticking out, which underscores her eccentric appearance. And instead of the cheery expression and outfit seen on the previous mom character on page 122 . . . well, actually, this is her cheery expression, too!

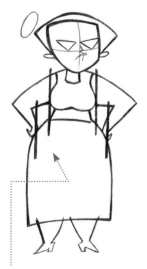

See how much wider the hips are than the waist? It's a funny look. Everything goes to her hips.

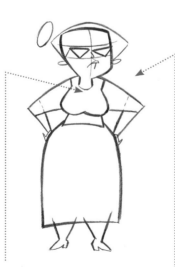

Plant her neck deep into the shoulder mass, giving her a hunched posture. Notice how I've given her an ample supply of arm mass.

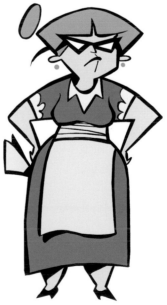

Point her feet sideways to suggest a waddle when she walks.

FUNNY SENIOR

If there's one word to describe the body of cartoon senior citizens, it's "thick" and "stiff." (I was never a math whiz.) Where'd the waistline go? Where'd the neck go? What happened to the rest of his forehead? I'll tell you where they went: They went to younger-looking cartoon characters. And, of course, the arched back is a typical feature on cartoon seniors. Why? Because cartoons are all about instant recognition. You've got to find some way to stereotype your characters' builds so that the viewer gets their roles and identities at a glance.

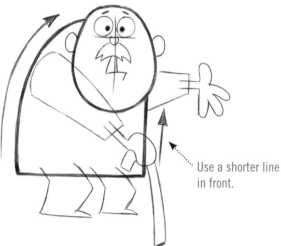

Notice the long arch of the back.

Use a shorter line in front.

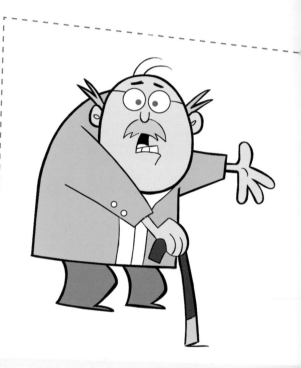

SENIOR DETAILS

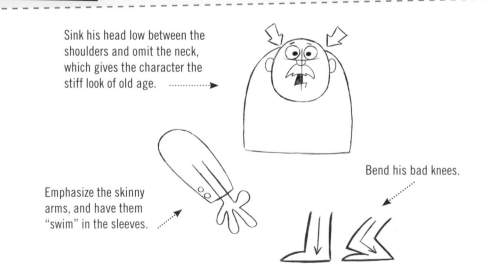

Sink his head low between the shoulders and omit the neck, which gives the character the stiff look of old age.

Emphasize the skinny arms, and have them "swim" in the sleeves.

Bend his bad knees.

MR. BENCH PRESS

These types are like hamburgers with heads. They're all meat and very little brains. But that's what's so entertaining about them. And believe me, it's more fun to draw them than it is to have to give your lunch money to them.

Of course, you have to draw him with big muscles, but the main thing that makes this character type work is his ridiculous upper-body shape. The second-most important aspect is how his arms and legs taper down to teeny-weeny hands—that can still bench-press 600 pounds.

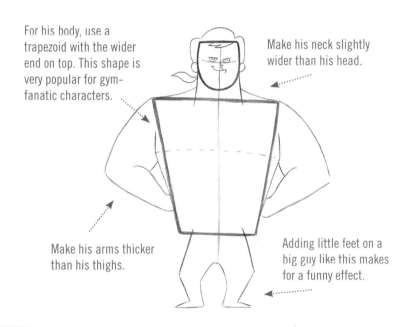

For his body, use a trapezoid with the wider end on top. This shape is very popular for gym-fanatic characters.

Make his neck slightly wider than his head.

Make his arms thicker than his thighs.

Adding little feet on a big guy like this makes for a funny effect.

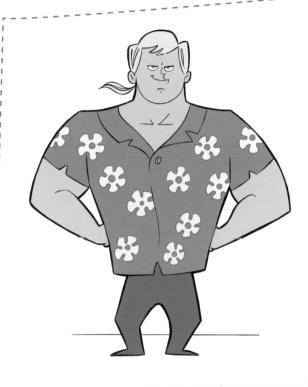

WEIGHTLIFTER DETAILS

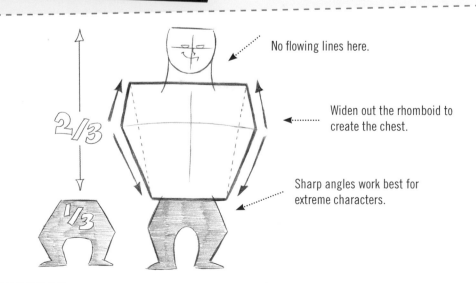

No flowing lines here.

Widen out the rhomboid to create the chest.

Sharp angles work best for extreme characters.

2/3

1/3

ADDING IMPORTANT DETAILS

So far, I've shown you how to create bodies from shapes. And it's been fun. I wonder if I'll ever enjoy anything that much again, or if this is all there is, followed, ultimately, by the sun becoming a red giant and incinerating the earth in the process. Ouch, that's grim. Let's get back to drawing!

Anyway, drawing the figure is about as far as most cartooning books take you. But I've developed special techniques to heighten the visual humor of a character. These have proven valuable for my work and I want to share them with you for the first time in this chapter. These special hints will make your drawings look so good that your friends will have a cow or start bawling with paroxysms of jealousy—and who among us doesn't want that?

THE LINE OF ACTION

It's hard to draw funny action if you don't also show a thrust to the drawing. Without a direction, an action simply lies there like a dead mackerel. And nobody likes to have his or her drawing compared to a fat fish. Don't let this happen to you! Use the line of action!

This line represents the basic direction the character assumes when performing some type of action. An action line can be severe, such as when drawn on a diagonal; or flowing, when it has one or more curves; or even stiff, such as when it's drawn with a straight line. You'll also find that certain lines convey one action more effectively than another. For example, a straight, vertical line is good for a funny walk, but a diagonal line is better for leaning into a run. Those, and many more examples, are demonstrated in this section. One last hint: For the best results, draw the line of action at the initial construction rather than later, when your pose is already set.

LEANING FORWARD

The most basic line of action is an ordinary curved line. It implies "stretch" movement. Stretching, bending, or leaning are all potentially funny poses, made funnier with a curved line of action to help emphasize them.

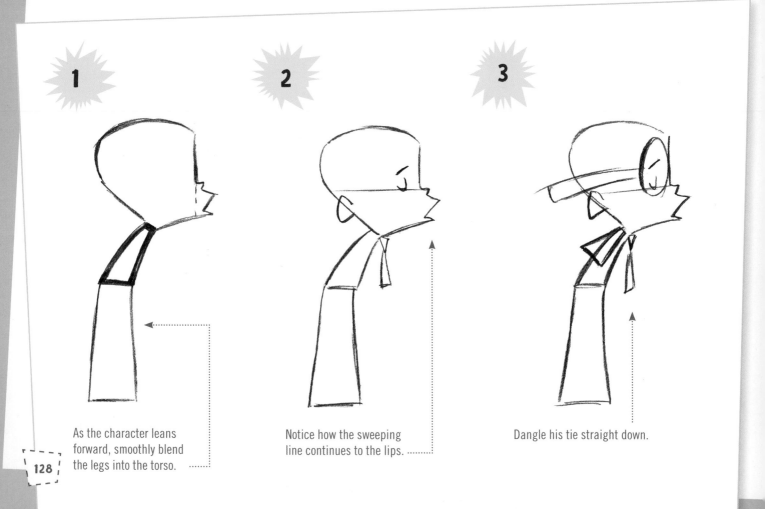

1

As the character leans forward, smoothly blend the legs into the torso.

2

Notice how the sweeping line continues to the lips.

3

Dangle his tie straight down.

128

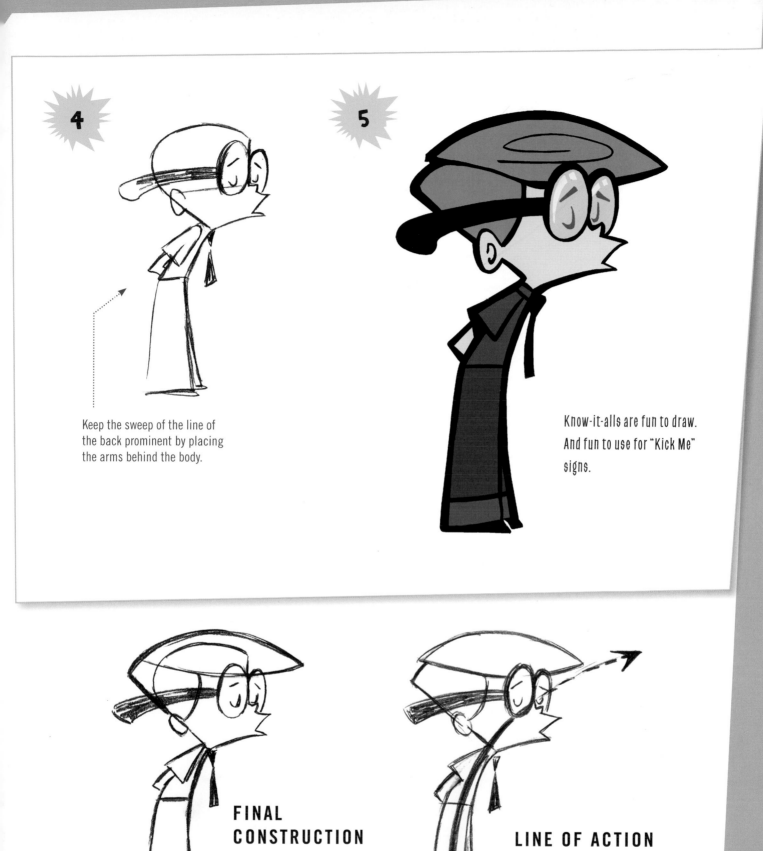

4

Keep the sweep of the line of the back prominent by placing the arms behind the body.

5

Know-it-alls are fun to draw. And fun to use for "Kick Me" signs.

FINAL CONSTRUCTION

LINE OF ACTION
Follow the flow.

REVERSE CURVE

I refer to this serpentine line as a reverse curve or, more often, as an S curve because it's easier to spell. A reverse curve has two curves in it. A single curve, by itself, is an effective line of action but does not convey flow, for which you need visual rhythm. Two curves convey rhythm, as the line first curves left, then gradually straightens, before curving right. And three curves convey a mixed-up person who doesn't know when enough is enough. And four curves—well, don't get me started.

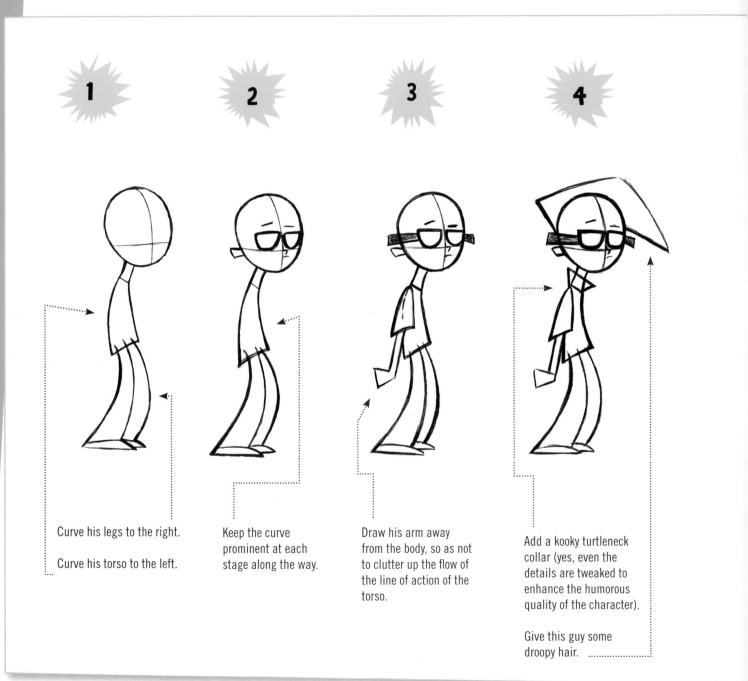

1

Curve his legs to the right.

Curve his torso to the left.

2

Keep the curve prominent at each stage along the way.

3

Draw his arm away from the body, so as not to clutter up the flow of the line of action of the torso.

4

Add a kooky turtleneck collar (yes, even the details are tweaked to enhance the humorous quality of the character).

Give this guy some droopy hair.

TWO APPROACHES TO DRAWING GLASSES

THE "BLANK GLASSES" APPROACH USES THINNER LINES FOR THE FRAMES AND PROVIDES A MORE DROLL EXPRESSION.

FLOATING EYES

BLANK GLASSES

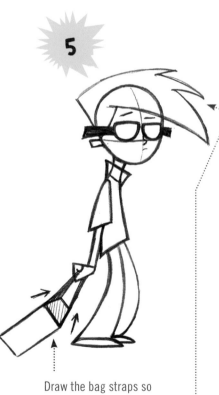

5

Draw the bag straps so that they converge.

Show progressive ruffles of the hair.

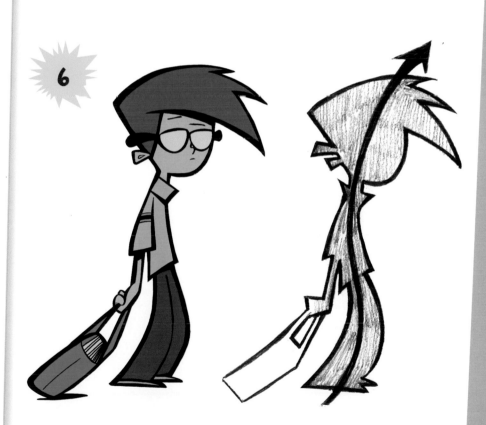

6

Reverse curves produce humor by eliminating all hard angles.

The winding line of action flows through the entire length of the body.

HALF LINE OF ACTION (UPPER BODY ONLY)

Many characters are drawn with straight, stiff legs as a part of their humorously quirky appearance. It would hurt the look of the character to suddenly draw him or her with a flowing line of action. So what's a cartoonist to do? Settle for a world without flow? Or destroy the integrity of your character, and therefore never be trusted again? Oh, vexing goddess, thy name is line of action! (That's from *Lear*.)

There is a third way. What you do is leave the legs stiff, but add a *half* line of action to the upper body.

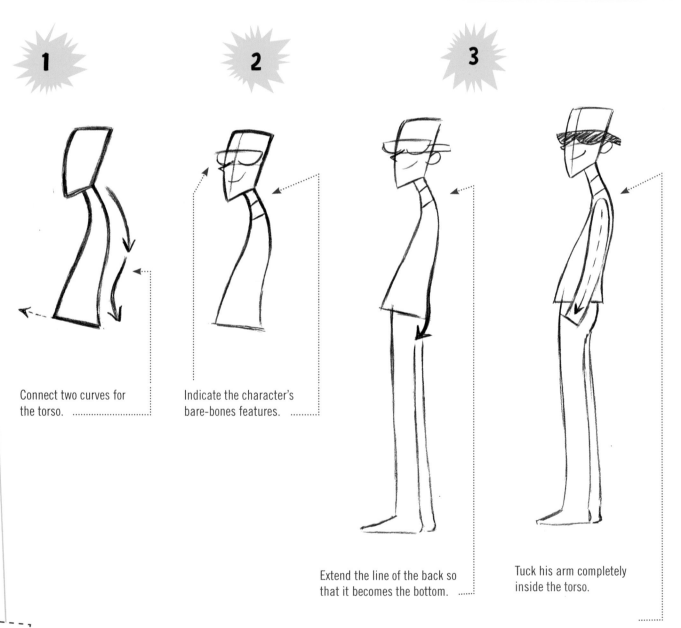

1 Connect two curves for the torso.

2 Indicate the character's bare-bones features.

3 Extend the line of the back so that it becomes the bottom.

Tuck his arm completely inside the torso.

4

Use irony to create humor: The harder the wind blows, the less he notices it!

5

Notice how the tie is blowing in the same direction as his hair.

HEAD CONSTRUCTION DETAIL

Use curved and straight vertical lines to create his head.

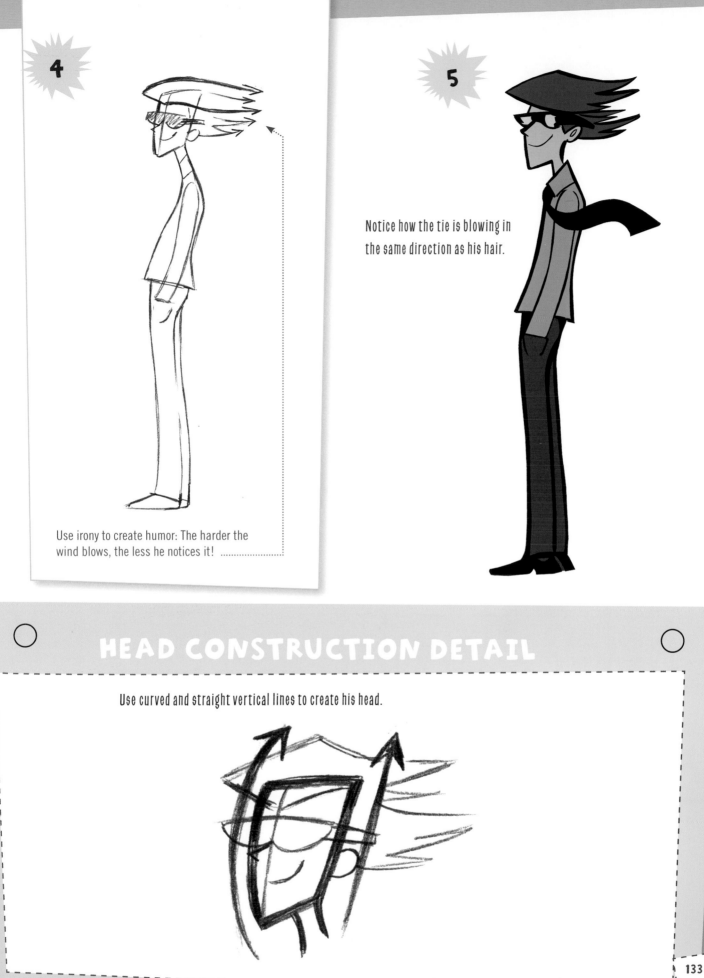

HUMOR AND HARD ANGLES --------------------------

Flow and lack of flow are opposites, as are matter and antimatter, or low-fat foods and taste. Flow and lack of flow can be funny when used together—so what's the worst that can happen? Total annihilation? Let's chance it! To create droll, funny, and amusing characters, try drawing the line of action with two straight lines that *do not flow together*. The jarring lack of flow is very entertaining. The waistline provides a break in the body and is, therefore, a natural place for the two opposing lines to meet.

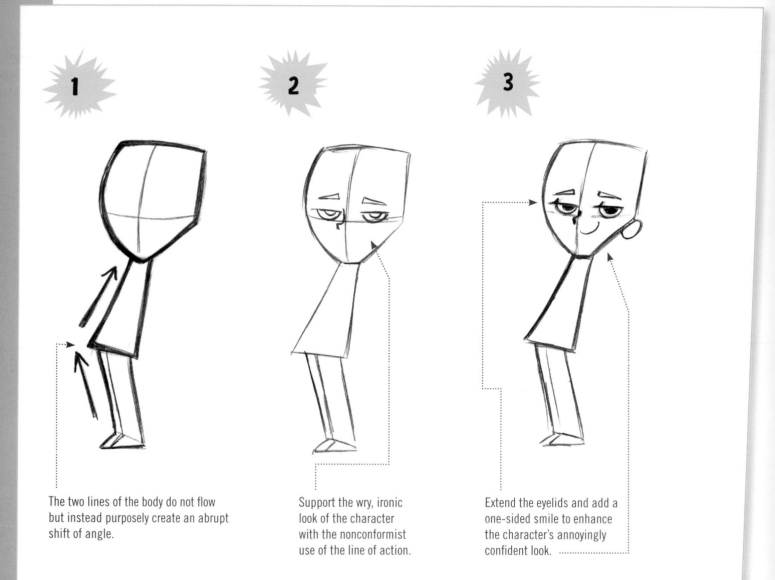

1

The two lines of the body do not flow but instead purposely create an abrupt shift of angle.

2

Support the wry, ironic look of the character with the nonconformist use of the line of action.

3

Extend the eyelids and add a one-sided smile to enhance the character's annoyingly confident look.

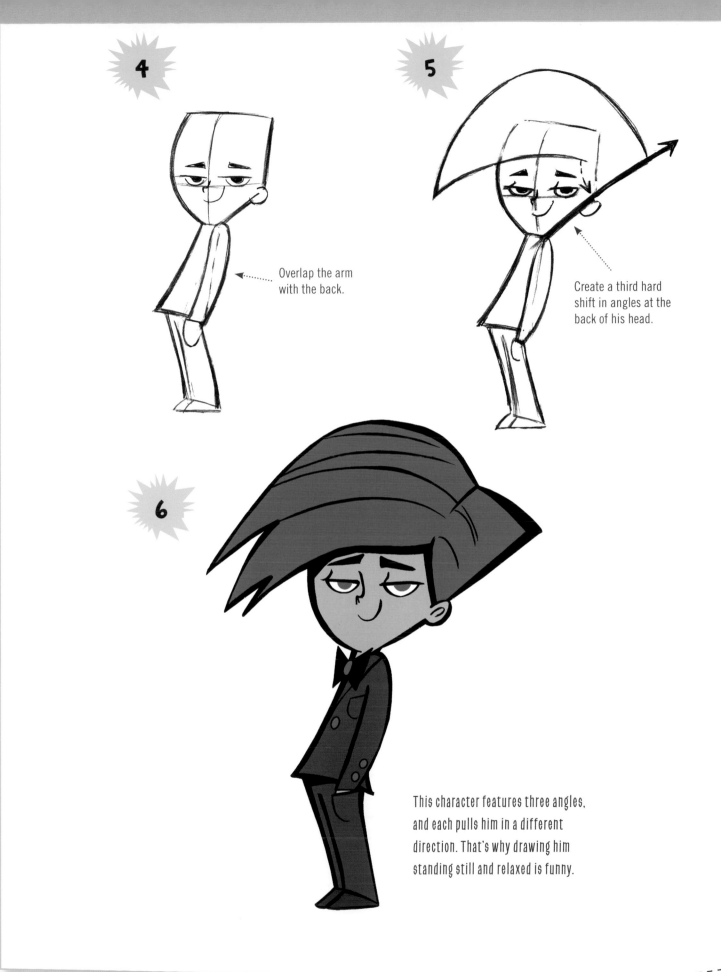

4 Overlap the arm with the back.

5 Create a third hard shift in angles at the back of his head.

6 This character features three angles, and each pulls him in a different direction. That's why drawing him standing still and relaxed is funny.

PRACTICE ACTION CARTOONS ------------------------

Welcome to the All-You-Can-Draw Buffet. Here, you'll find a plentiful variety of cartoon characters in funny actions. Each character is funny but basic. Try to concentrate on sticking true to the line of action for each example you draw.

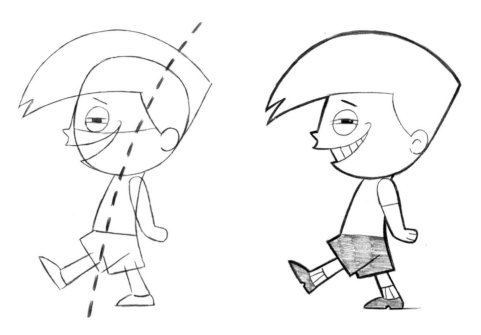

FUNNY WALK

The slight backward curve to his gait shows that he's not going to be getting anywhere fast.

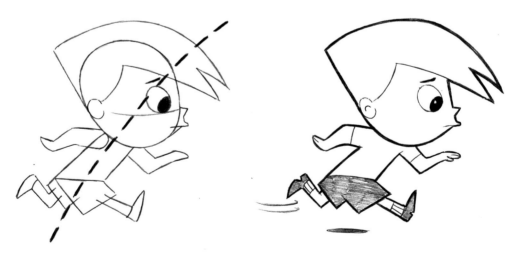

FUNNY RUN

By curving the line forward, you can increase the appearance of his pace.

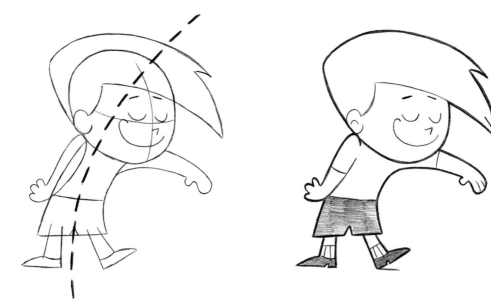

FUNNY THROW

Instead of leaning into the pitch with an extreme line of action, he's actually using a more casual throw. Hence, the only slightly curved line of action.

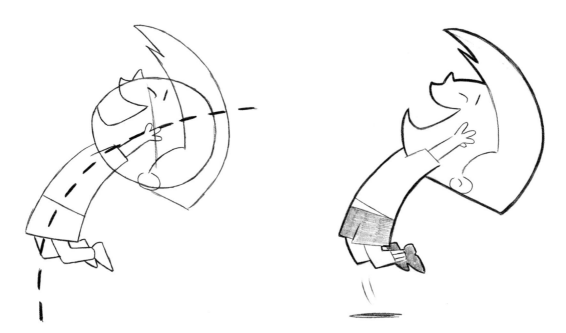

JUMPING FOR JOY

An extreme curve in the line of action is used for moments like this one.

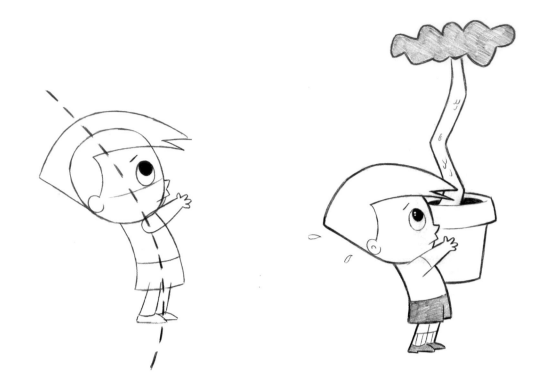

ACTUALLY DOING A CHORE (HARD TO BELIEVE)

The boy leans back to carry the huge potted plant.

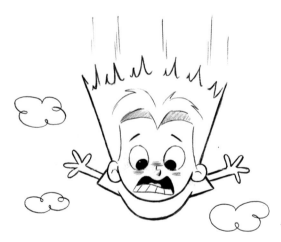

SKYDIVING WITHOUT A PARACHUTE

Last time I tried this, I found out that I wasn't as bouncy as I thought. You can use a straight line to represent an extreme action.

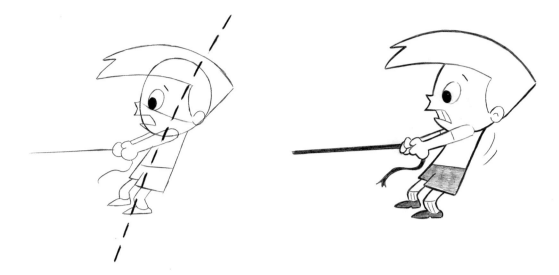

A TUG ON THE ROPE

The boy leans back in order to show the action of pulling.

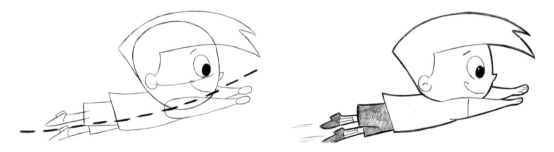

FLYING BOY

A horizontal line indicates a calm and stable sense, which works with this experienced flyer. Position him on a slight diagonal to avoid a static look.

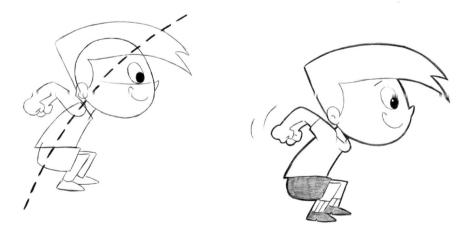

READY TO JUMP

This is an action before the action. Any time a character gets ready to launch into a pose, show a lot of action, which is often best represented by a curved line of action.

STRETCHING AND CONDENSING THE BODY

By elongating one part of the body while shortening another, you add punch to your character. If the upper body is long, the legs should be way short. If the legs are long, the upper body should be way condensed. If nothing is exaggerated, the character isn't very interesting. However this technique is not something that I would recommend using all the time. That would lessen its impact. When you do it, make it extreme so that it doesn't become a subtlety lost on the viewer. I know, I know, you've always been told to do things in moderation. Okay, fine. Just don't do moderation in excess.

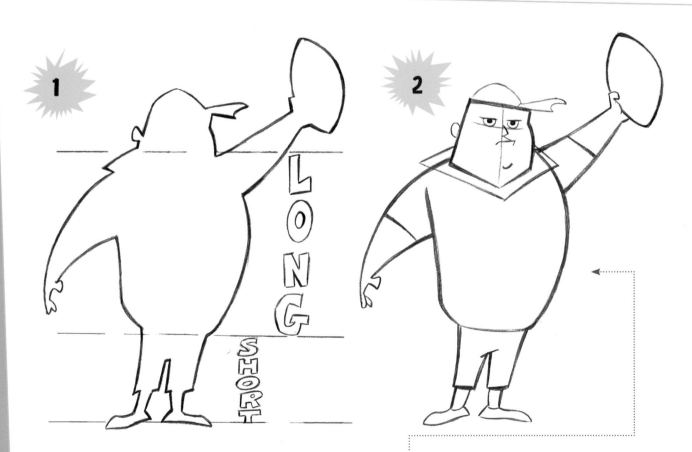

Notice how the torso is twice as long as the legs. If you include the head in the measurement, he's one-fourth legs, and three-fourths everything else (except the hat).

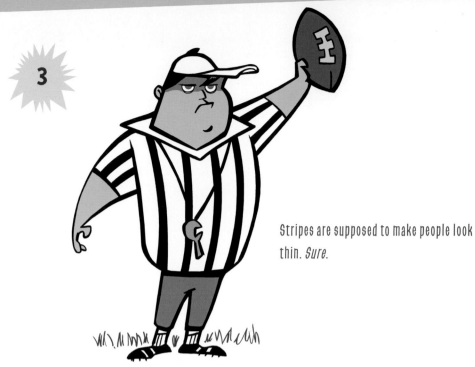

3

Stripes are supposed to make people look thin. *Sure.*

THE SHORTENED FEMALE TORSO

On female characters a condensed figure can actually increase their attractiveness. Condensing creates a petite look for the torso, while making the legs appear longer by contrast. Finish by drawing her arms and legs in a casual, feminine position, as shown in the example on this page. The technique works so well that you won't even realize that her torso has been condensed to the point where it's the same size as her head!

Notice how her torso is condensed mostly in the midsection, with the chest and hips maintaining normal size.

A stylish tilt of the torso is more pronounced on truncated figures.

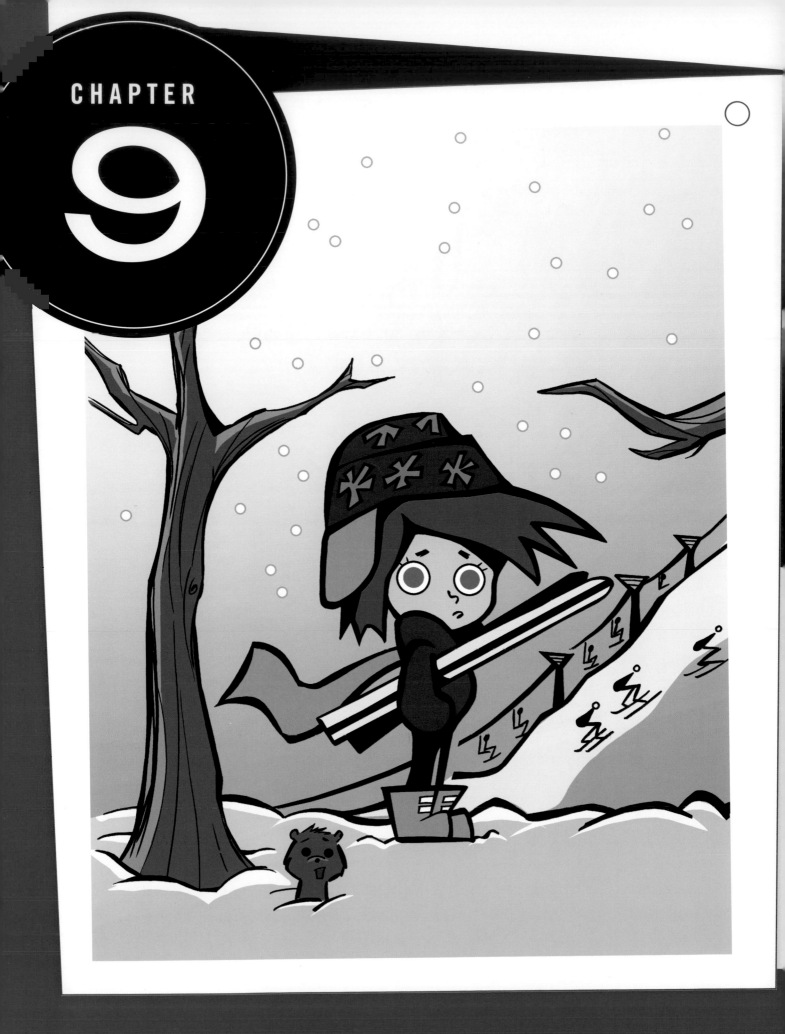

SAVING THE BEST FOR LAST: STUFF YOU WON'T LEARN IN ART SCHOOL

In this final chapter, you'll start with some essential fine points to use as you finish your characters. Then I'll show you how to put it all together by creating funny scenes in which to place your characters. This will create a context for your characters, and cause viewers to linger on your images for an extra beat. Feel free to add to or adjust the backgrounds and characters with your own ideas. Yep. You're ready to do that!

Step-by-step, I will show you how to utilize everything you've learned to create maximum impact and humor. Drawing from both the basics and the specific hints, the characters will appear to take on a life of their own through their humorous constructions, expressions, actions, and now the settings they occupy.

As you venture forth in cartooning, you will find these last tips quite useful in giving your artwork that professional touch. The point of these next few pages is to show you that every aspect of a drawing can be worked on to develop and refine your characters. This can give you what you have been looking for: eye-catching cartoons and complete global domination.

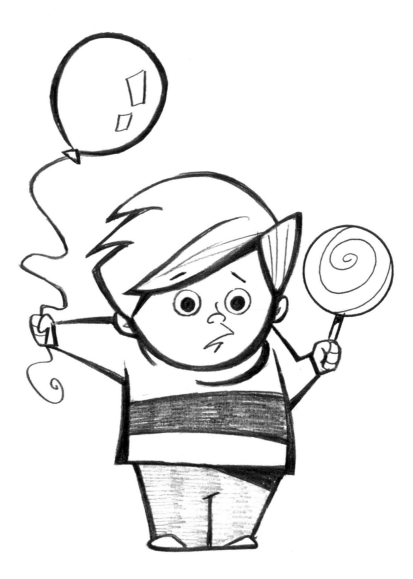

NOTES ON THE HEAD

I've chosen this little boy character and asked him to volunteer to be deconstructed for your benefit. Being rather shy, he demurred at first. I offered to draw him a brand-new bicycle. Still, he politely declined. When I started to erase his head, he suddenly got all reasonable and everything. Oh, the power we cartoonists have in our pencils.

First up, when refining a character's head and face, the overall construction, not just the eyes, nose, and mouth, should be considered as one of the basic features.

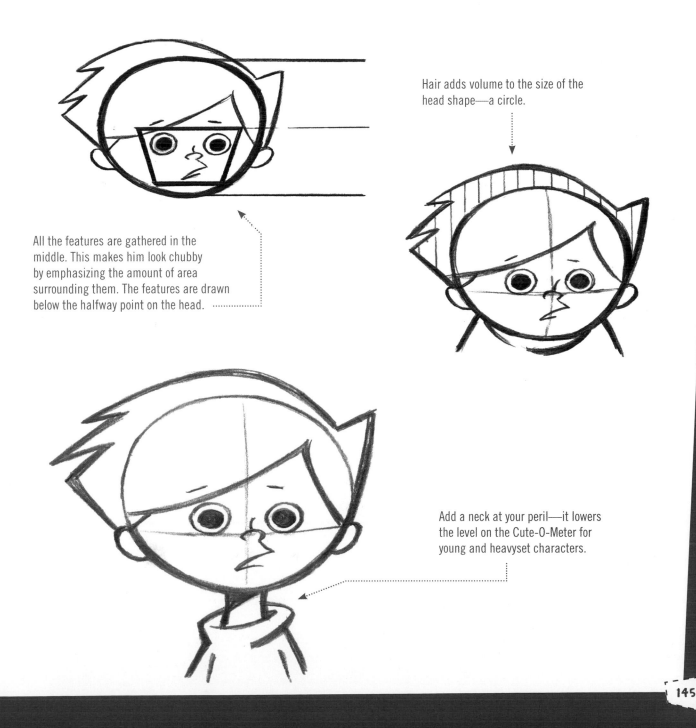

Hair adds volume to the size of the head shape—a circle.

All the features are gathered in the middle. This makes him look chubby by emphasizing the amount of area surrounding them. The features are drawn below the halfway point on the head.

Add a neck at your peril—it lowers the level on the Cute-O-Meter for young and heavyset characters.

NOTES ON THE BODY

These diagrams serve as a reminder of just how tall and how wide the character is. The height of the character is not measured in inches, or centimeters, or even in "tads," as in "he's a tad taller than that." Instead you measure a character by how many of its own heads can be stacked up beside it. In this case, the answer is two, so this character would be referred to as "two heads tall."

Then there's the width of the character. This diagram compares the width of the head to the rest of the body. The girth needs to remain consistent; otherwise, it might appear that your cartoon is on a yo-yo diet.

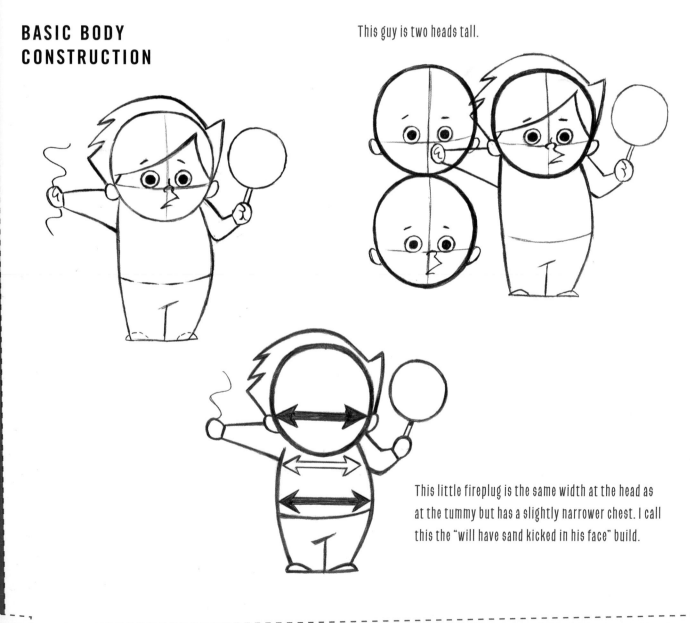

BASIC BODY CONSTRUCTION

This guy is two heads tall.

This little fireplug is the same width at the head as at the tummy but has a slightly narrower chest. I call this the "will have sand kicked in his face" build.

DETABILS

Now indicate some traits that are perhaps more nuanced but still make a positive difference in the ultimate appearance of the character. These details can feature any aspect of the character that you find particularly appealing or that makes him unique. In one character it might be the style of glasses, in another it might be how short the tie is, and in still another it might be the way the hair always flops over one eye. These aren't the fundamental building blocks of the character, but they are important nonetheless.

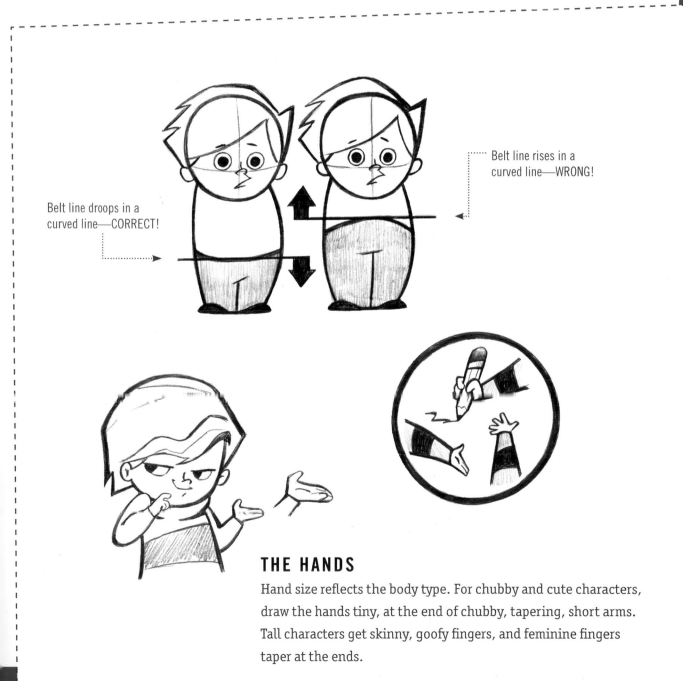

Belt line droops in a curved line—CORRECT!

Belt line rises in a curved line—WRONG!

THE HANDS

Hand size reflects the body type. For chubby and cute characters, draw the hands tiny, at the end of chubby, tapering, short arms. Tall characters get skinny, goofy fingers, and feminine fingers taper at the ends.

DRAWING THE CHARACTERS IN THEIR OWN SCENES

You've come a long way to get this far in the book.

But first there's one more subject for you to tackle: creating scenes for your characters. Keep the backdrop basic and without complexity so that it won't pull the focus of the viewer's eye away from the main characters.

A BIG KISS FOR WITTLE SISTER

Why is this picture funny? That's an important question. The ability to plan your drawings in order to cause desired responses in your viewer is a skill you'll want to develop. The appeal of this piece comes from what's unsaid: Big sister is giving baby brother a big, affectionate kiss on the cheek to get strokes from her folks. The minute they leave, she'll be back to her nasty self!

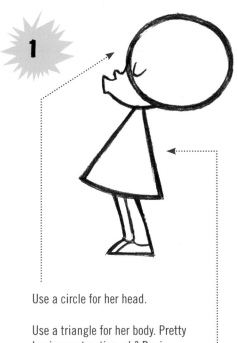

1

Use a circle for her head.

Use a triangle for her body. Pretty basic construction, eh? Basic constructions can be highly effective.

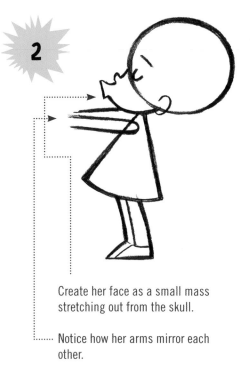

2

Create her face as a small mass stretching out from the skull.

Notice how her arms mirror each other.

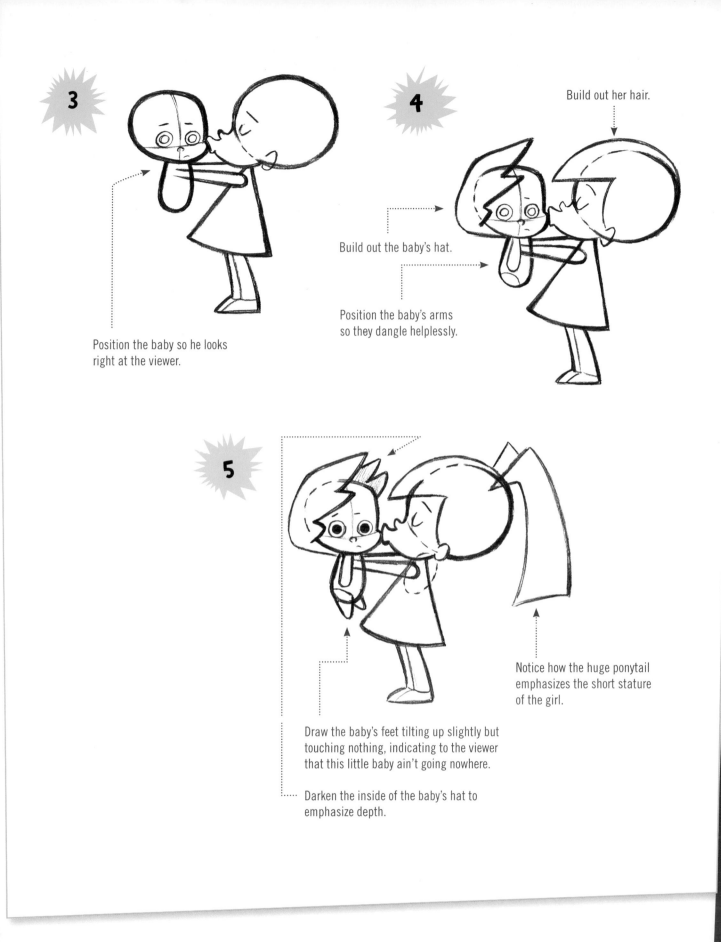

3

Position the baby so he looks right at the viewer.

4

Build out her hair.

Build out the baby's hat.

Position the baby's arms so they dangle helplessly.

5

Notice how the huge ponytail emphasizes the short stature of the girl.

Draw the baby's feet tilting up slightly but touching nothing, indicating to the viewer that this little baby ain't going nowhere.

Darken the inside of the baby's hat to emphasize depth.

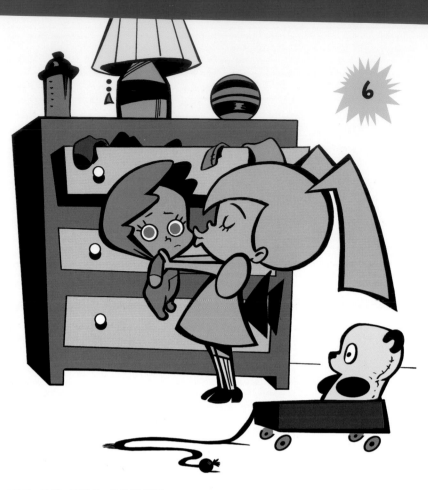

Note that the outline of the big sister's figure is not completely inside of the lines of the dresser, which act as a framing device. Breaking through those lines makes a composition more energetic.

NOTES ON THE SCENE

You can draw this freehand or use a ruler, as I have, to create the straight lines. But don't mix the two techniques. Because if you do, then the ruler-straight lines will appear to be correct, and the hand-drawn lines will appear to be mistakes. And that, my friends, could spell doom.

A finished dresser: very symmetrical, very correct, very boring.

BORING

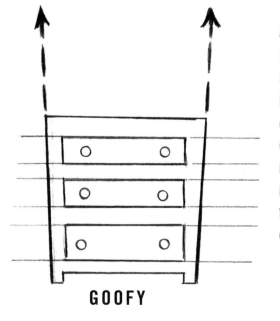

GOOFY

A kooky approach works for many items in a cartoon scene. However, since the scene itself is so goofy, you won't draw attention away from the characters by making it too nuts. Notice, though, that it is lopsided in such a way that the total mass on each side is equivalent.

Here, the drawers are uneven sizes and, yes, they're also somewhat slanted. Plus, the vertical lines of the bureau expand as they rise. Even the verticals of the drawers are slanted.

GOOFIEST!

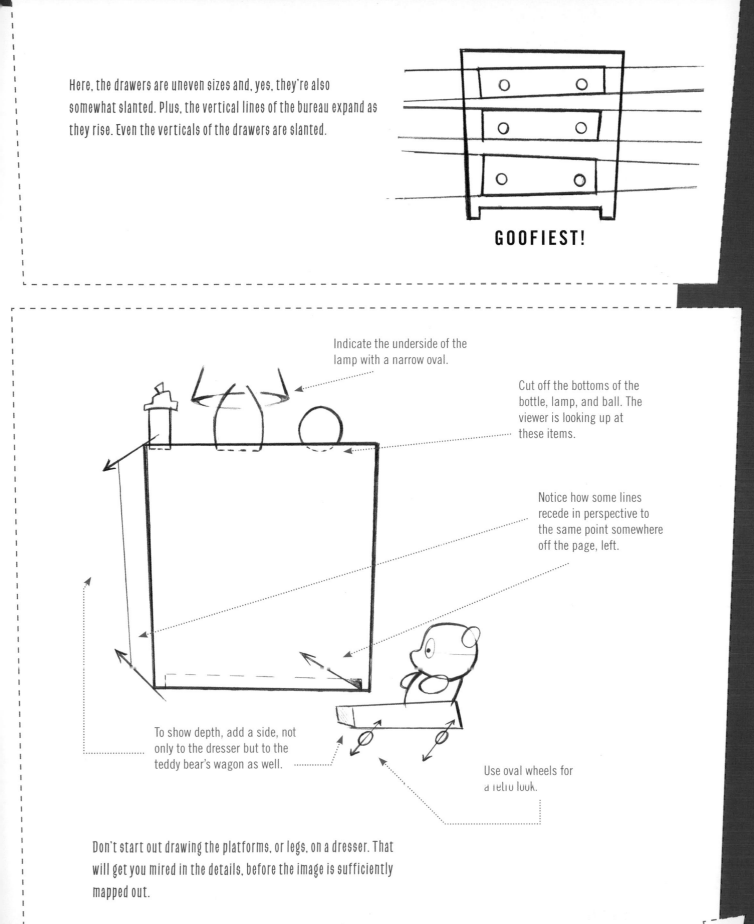

Indicate the underside of the lamp with a narrow oval.

Cut off the bottoms of the bottle, lamp, and ball. The viewer is looking up at these items.

Notice how some lines recede in perspective to the same point somewhere off the page, left.

To show depth, add a side, not only to the dresser but to the teddy bear's wagon as well.

Use oval wheels for a retro look.

Don't start out drawing the platforms, or legs, on a dresser. That will get you mired in the details, before the image is sufficiently mapped out.

COULDN'T WE JUST PLAY CATCH INSTEAD?

Let's put this cute, perplexed little fella in a scene where he looks intimidated by the task ahead of him. It's a funny scene mainly because of the character's wide eyes and tiny mouth position. He obviously doesn't want to be there and doesn't want to be skiing. Personally, I can't understand not wanting to ski. How can you not want to go where it's so cold that you have to wear a ton of bulky clothes and travel up a mountain only to travel back down again. Ten times in a day. What's not to like about that?

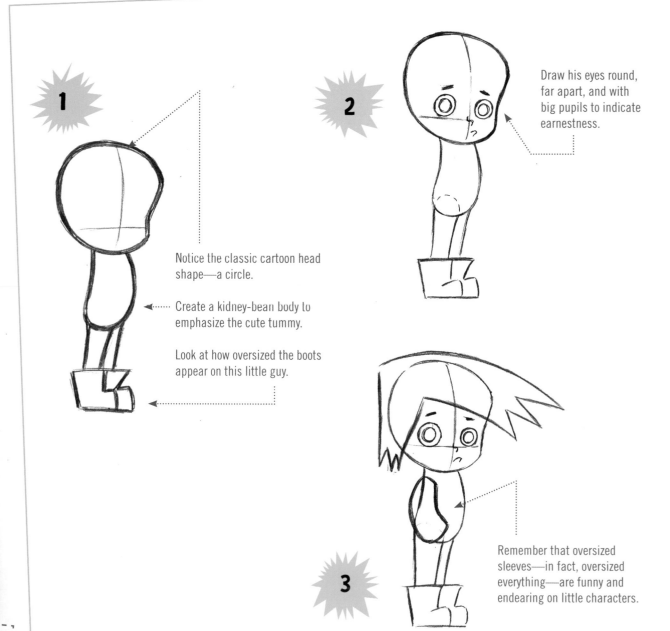

1

Notice the classic cartoon head shape—a circle.

Create a kidney-bean body to emphasize the cute tummy.

Look at how oversized the boots appear on this little guy.

2

Draw his eyes round, far apart, and with big pupils to indicate earnestness.

3

Remember that oversized sleeves—in fact, oversized everything—are funny and endearing on little characters.

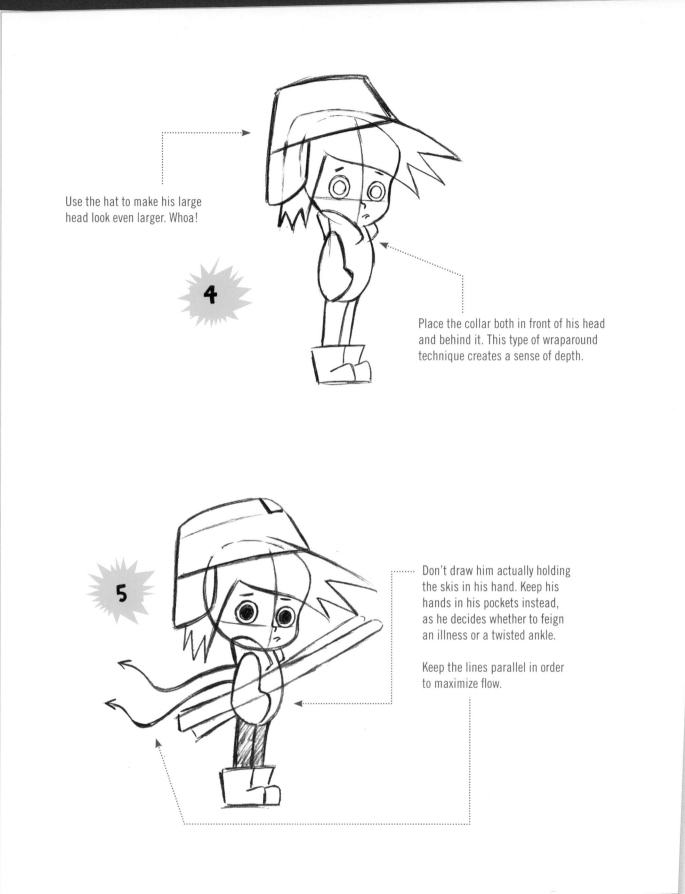

Use the hat to make his large head look even larger. Whoa!

4

Place the collar both in front of his head and behind it. This type of wraparound technique creates a sense of depth.

5

Don't draw him actually holding the skis in his hand. Keep his hands in his pockets instead, as he decides whether to feign an illness or a twisted ankle.

Keep the lines parallel in order to maximize flow.

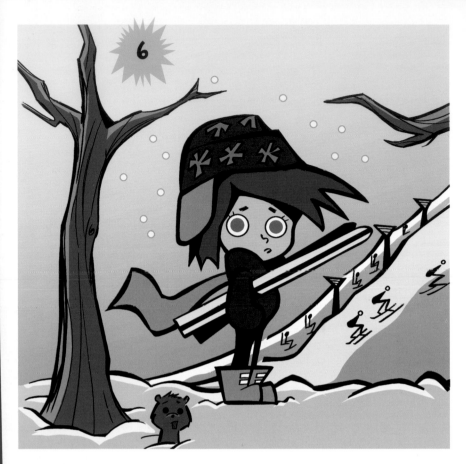

Details are important. For example, the chairlift in the background is going up the mountain while the skiers are going down. The boy, trapped into doing something he'd rather not do, is also framed by the trees on either side, sort of boxing him in, which is called "bookending the character." It's essential to get the look of the snow right. It's drawn with medium-size uneven bumps that are not too high and somewhat horizontal. Tiny bumps are a no-go, as they make fallen snow look like cottage cheese. Which is okay, I guess, if your audience is really into cottage cheese, which, trust me, they are not.

The diagonal line of the mountainside overlaps the boy's legs on purpose: It ties him into the scene—whether he wants to be there or not. The scarf flapping in the breeze adds some action. And this little bit of motion is important, otherwise the boy would look like a statue.

NOTES ON THE SCENE

These notes will give you an idea of how to draw the various elements that create this humorous situation. And one of those elements is the humorous sidekick: a little gopher. It pops its head up from the snowy ground and mimics the boy's confused look at the viewer, tying the two characters together. Can you guess what the addition of the gopher does? It turns this into a "Buddy Scene." Otherwise, the drawing is just a boy against a landscape, which scores just a tick lower on the Fun-O-Meter.

THE SNOW
Avoid drawing the snowflakes falling in perfect order; instead make their positioning appear random.

THE TREE

Draw the grain on the tree slightly uneven so it looks more natural—and more interesting.

Place branches at the top of the tree trunk and fan them out in different directions.

Make the snow rise up from the base of the tree so that it appears firmly planted in the ground.

THE GOPHER

Give the character fat cheeks!

Notice how the snow rises up, as with the tree, to make him appear sunken into it.

Ta-da! Simple constructions are important for characters who appear small in a scene, so that the viewer can make them out at a glance.

HECK'S ANGEL

Nice bike, huh? Watch out, because this speed demon may be cruising through your town next, and he stops for no one!

First, focus on drawing the character's amazing shape, like a teardrop cut off at the top. This is the key to his appeal, even more so than the funny outfit or kooky hair. Do you remember, earlier in the book, the discussion of characters where the entire head and figure are based on a single shape? This is a good example of that approach.

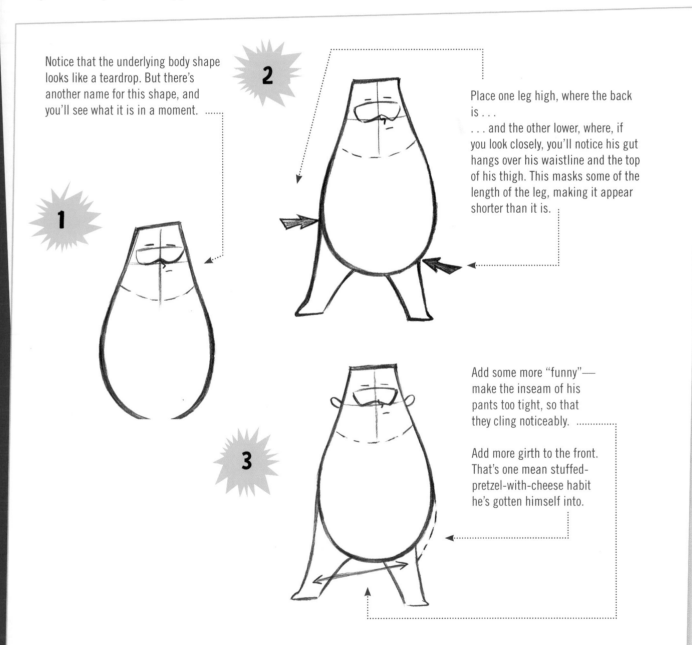

Notice that the underlying body shape looks like a teardrop. But there's another name for this shape, and you'll see what it is in a moment.

1

2

Place one leg high, where the back is . . .

. . . and the other lower, where, if you look closely, you'll notice his gut hangs over his waistline and the top of his thigh. This masks some of the length of the leg, making it appear shorter than it is.

3

Add some more "funny"—make the inseam of his pants too tight, so that they cling noticeably.

Add more girth to the front. That's one mean stuffed-pretzel-with-cheese habit he's gotten himself into.

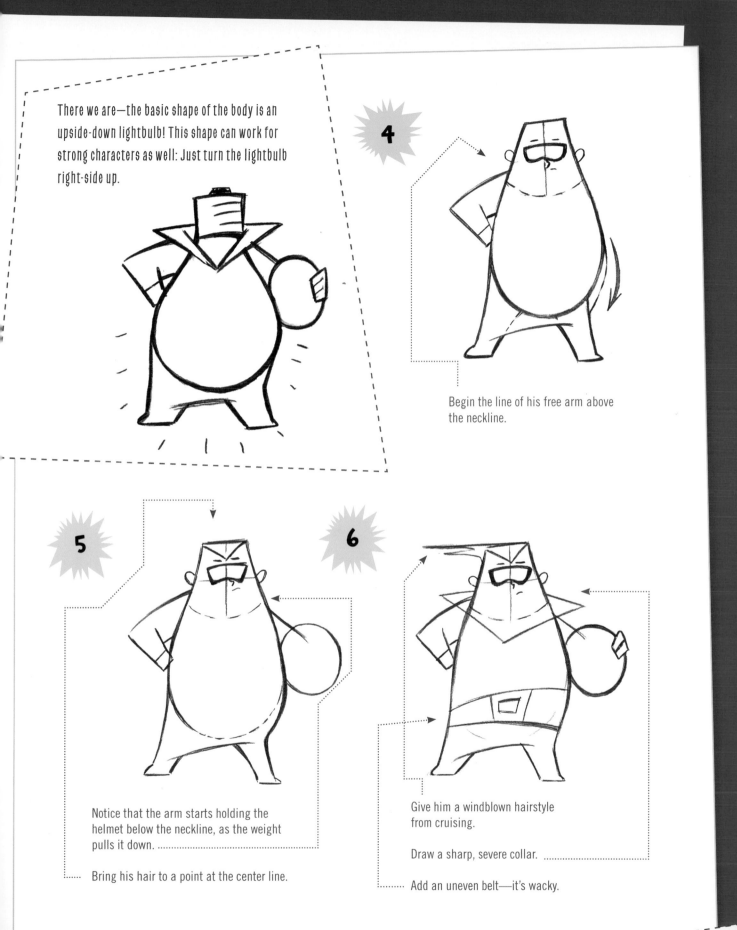

There we are—the basic shape of the body is an upside-down lightbulb! This shape can work for strong characters as well: Just turn the lightbulb right-side up.

4

Begin the line of his free arm above the neckline.

5

Notice that the arm starts holding the helmet below the neckline, as the weight pulls it down.

Bring his hair to a point at the center line.

6

Give him a windblown hairstyle from cruising.

Draw a sharp, severe collar.

Add an uneven belt—it's wacky.

7

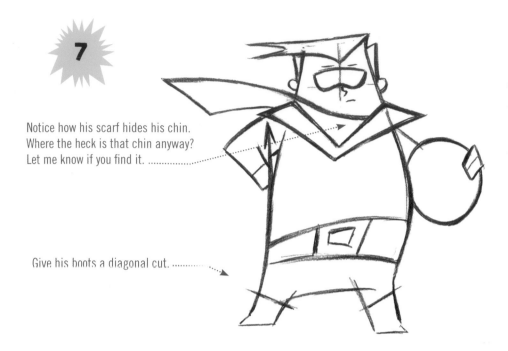

Notice how his scarf hides his chin. Where the heck is that chin anyway? Let me know if you find it.

Give his boots a diagonal cut.

Before you finish this drawing, let's pause to consider if we're on our way toward achieving our underlying goal: to be funny, visually.

Some people believe that they have to feel an expression in order to draw it. They have to *be* the expression, think the expression, and yes, smell the expression. But we'll use comedic strategy instead. Here's how: This character is extremely broad. If his expression were also broad, then the reach for the joke would appear too strained. Therefore, play it straight: He's the head of a marauding motor-scooter gang—don't mess with him!

8

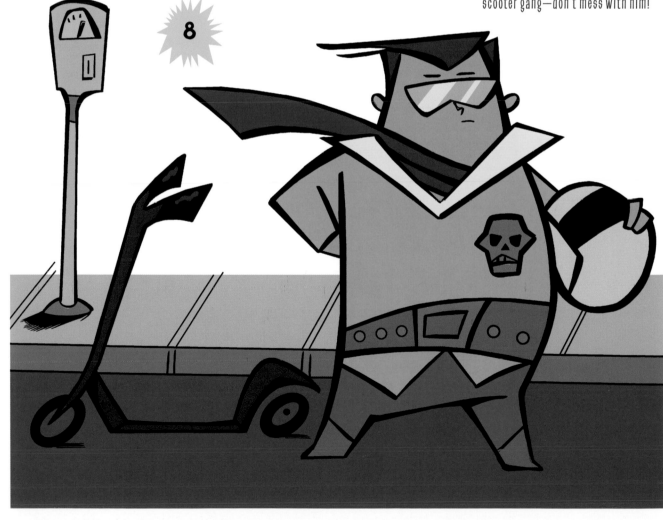

NOTES ON THE SCENE

This is an example of how a backdrop can convey ideas about the subject in the foreground. That gnarly scooter parked by the meter makes the biker that much funnier. He is as liable to crush the vehicle, as he is to ride it. The sidewalk is also a strong image—how do I know this? Because it doesn't require a backdrop of stores in order to visually articulate the scene, whereas stores, without the sidewalk, would look incomplete. Note, too, the shadows under the tires, which give grounding to the biker's mean machine.

SCOOTER AND PARKING METER

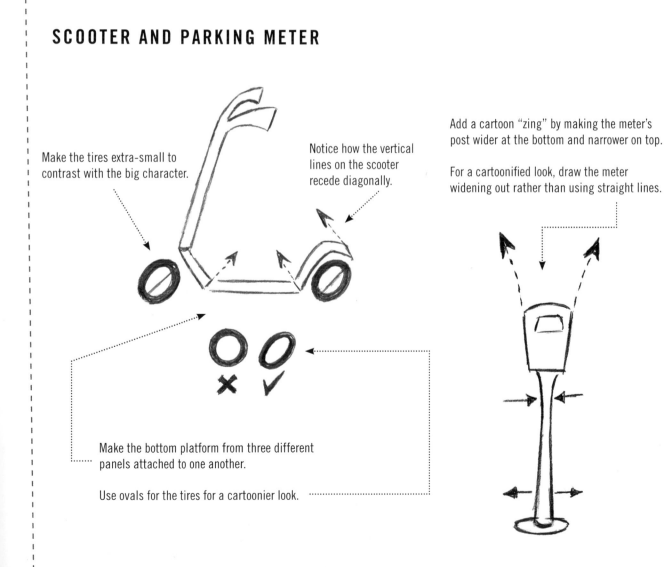

Make the tires extra-small to contrast with the big character.

Notice how the vertical lines on the scooter recede diagonally.

Add a cartoon "zing" by making the meter's post wider at the bottom and narrower on top.

For a cartoonified look, draw the meter widening out rather than using straight lines.

Make the bottom platform from three different panels attached to one another.

Use ovals for the tires for a cartoonier look.